Donated by
NORTHLAND PUBLISHING COMPANY, INC.
A subsidiary of Justin Industries, Inc.

Including the following corporations:
Acme Brick Company · **Featherlite Building Products Corporation**
Justin Boot Company · **Nocona Boot Company**
Tony Lama Company, Inc. · **Tradewinds Technologies, Inc.**

"I may never see you again,
but you will be my friend forever."

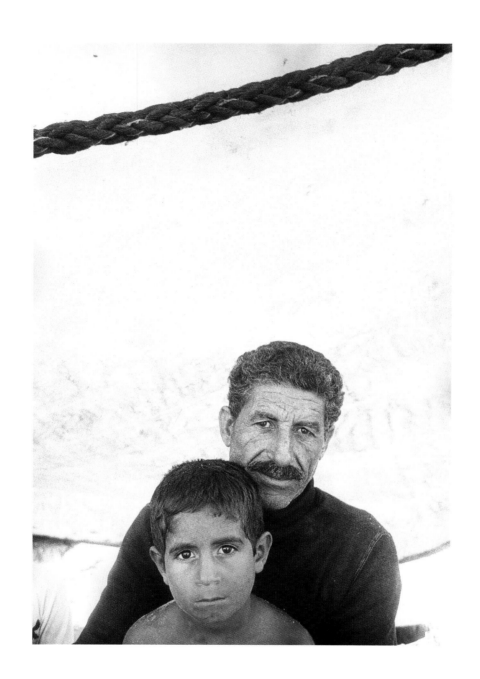

Pictures for Solomon

By JOHN RUNNING

Foreword by Jay Maisel

 Northland Publishing

FRONTISPIECE: Gaza fisherman and son,
Occupied Gaza Strip.

For information, address
Northland Publishing Co.,
P.O. Box N, Flagstaff, AZ 86002.

FIRST EDITION

ISBN 0-87358-511-9
Library of Congress
Catalog Card Number 90-53283

Composed and printed in the
United States of America

Library of Congress Cataloging-in-Publication Data

Running, John.
Pictures for Solomon/by John Running. — 1st ed.
144 p.
ISBN 0-87358-511-9
1. Photography — Portraits. 2. Palestinian Arabs —
Portraits.
3. Mexicans — Portraits. 4. West Indians — Trinidad and
Tobago — Portraits. 5. Running, John. 1. Title.
TR680.R86 1990
779!2'092 — dc20

90-53283
CIP

In memory of my Father,
Richard E. Running

Contents

~~~~~~~~~~~~~~~~~~~~~~~~~~~~~~~~~~~~~~~~~~~~~~~~~~~~~~~~~~

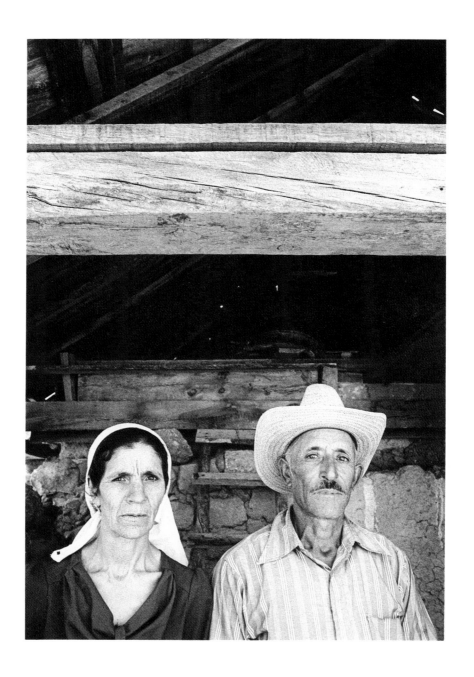

MR. AND MRS. ALGODIN, *Sierra Madres, Mexico.*

# Acknowledgments

FIRST, I want to thank all of the people who allowed me to make their picture. I want to thank them for their image, for their stories, and for their hospitality. I may never see them again, but they are my friends forever.

There are many other people to thank for all kinds of reasons: Peter and Sarah Dixon, who sent me to find fishing families for the book series Children of the Sea; Tim Means of Baja Expeditions, for getting me to Pardito; Dennis Lau, for introducing me to the people of Matelot; Jay Maisel, for his foreword that makes me feel both pride and responsibility, but mostly for his extraordinary photographs that inspire us all; Sue Bennett, for being my co-conspirator on the Palestinian project—we traveled together, discovered together, made pictures together, and struggle to bring our work before the public together—for her love and friendship and belief in my work, for being my mentor and a motivating force in my life.

Other people that come to mind: my mother, Grace Marie Running, who taught me that books are friends; my children, Raechel Marie and John Paul, who as adults continue to bring me joy and fresh new insights; my friend Rick Stetter, who remains elusive; Sue Bassett, who keeps me and my studio organized; Peter Rosenthal, who keeps my cameras and lenses repaired; and Larry Stevens, Dave Edwards, Ward Sumner, Eric Kroll, Mark Hauser, Dawn Kishbaugh, Michael Collier, Bill Gillette, and Bill Franklin, who add to my work.

Where do books come from? Not from bookstores or libraries. Books are published because of the efforts of many people. They are born of a careful collaboration, meticulous organization, and hard work. I want to thank the people who collaborated with  me on this book. I had all these pictures in my files when Bruce Andresen and Susan McDonald from Northland Publishing invited me to do a book for them. Betti Albrecht edited the text, and Dave Jenney integrated the words and pictures into a cohesive whole.

# *Introduction*

~~~~~~~~~~~~~~~~~~~~~~~~~~~~~~~~~~~~~~~~~~~~~~~~~~~~~~~~~~~~~~~~~

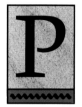ICTURES FOR SOLOMON. I make pictures for Solomon, a spiritual mentor that I met some time ago on the beach of Baja California. Wise Solomon made me realize more than anyone else that the pictures I take are an exchange with the people I photograph. This book is really a collection of gifts, something like a gift catalog, except that what you see here has already been given. I want to thank all of the people who have given me their image and stories.

I never planned to be a photographer. At first I wanted to be a geologist, because I thought geologists worked outdoors and traveled. I studied geology in the late fifties, then joined the Marine Corps in the early sixties. While in the marines, I realized that I wanted to work with people rather than rocks. After my tour of duty, I moved to Flagstaff, Arizona, where I completed a degree in anthropology.

During my third year at Northern Arizona University, I had the opportunity to apprentice myself to a German photographer/cinematographer. I took a year off school to work for him. We worked for the United States Geological Survey and made films that taught geology to the Apollo astronauts. My rationalization at the time was that I would combine my anthropology degree with my skills as a cinematographer and photographer and make anthropological films. It was a good plan, I thought, except that I became disenchanted with the academic side of anthropology and increasingly more intrigued with the idea of being a photographer.

As the Apollo program neared completion in 1969, funds were cut along with my job. In June 1970, I left the U.S. Geological Survey to become a freelance photographer.

To see, to record, to comment. These are my pursuits as a documentary photographer. I watch and take pictures. Watching: that's my job. Watching is an active and receptive participation with the people I am photographing. The Navajo Indians taught me how to watch—it's allowed in their culture. I have spent days and weeks on the Navajo Reservation, days before I ever made a picture, just squatting and watching or working and watching. I herded sheep, worked cattle, chopped wood, picked corn, and watched. There was nothing else to do. I didn't speak Navajo, so I immersed myself in the people and place and watched.

My approach is the same for commercial/industrial work, since I need to see and learn about a subject before I can make any kind of meaningful photograph. But learning is one of the things I enjoy the most about being a photographer. I like meeting people and experiencing new places; and, since I enjoy my work, I find I am as enthusiastic about my commercial work as I am about my personal work.

To do this, I bring my tools—camera, film, lens—to the task and apply all I know about design, composition, and framing and then "click." Then it is to the darkroom or the lab to fix the pictures on pieces of acetate or paper. So for me, the camera is just a tool. In many ways, it is an extension of my eyes, an extension of my feelings and experiences. What I do is not art. It is not entertainment. Rather, I use the camera to show things that cry out to be appreciated. I make my pictures as simple and direct as possible and then leave it to you to read your experiences into them. I try to use my camera to energize film with light, so the light reflected off my pictures activates the rods and cones on the retinas of your eyes and makes them dance.

Making a photograph is usually a collaboration between the photographer and the subject. It doesn't matter if the subject is a landscape, a still life, an animal, or a person. I make photographs of people. When I make photographs of

people I usually spend some time with them—five minutes, an hour, a couple of days, or weeks. Often the circumstances of my photographs become embedded in memory. I remember the sounds, a person's voice, the smell of the place, the feel of the air. My pictures evoke memories. You are at a disadvantage when you see my photographs, but I want you to feel all of the things I felt when I took them. I can recall the circumstance of my picture and I want to etch my pictures into your mind, to touch your emotions.

What makes a photograph memorable? Not a spectacular news shot, nor a wire-service photograph made by a war correspondent, nor even a celebrity portrait made by a celebrity photographer, but, quite simply, the photograph of a man or a woman—a portrait, a simple picture of a person. I love to make pictures of people, portraits of babies, children, young people, couples, old folks, my neighbors, people from the town I live in, or people living in far away places and exotic locations. It's the people and their faces that make a great photograph. Faces read like poetry in that they reveal the whole dimension of human emotion.

When I travel, people always seem to give me things, often the most personal of gifts—their image. When they answer yes to my request to photograph them, they are offering their gift. It is as though they say, take this, I'll share it with you, take this and show it to the world. So I become the happy recipient of their gifts and make the pictures. But then I feel obligated to give something in return. Sometimes I leave a Polaroid picture, but typically I don't have anything that tangible. Usually the only thing I have to share or trade is elusive and nonmaterial: my respect, my friendship, my sense of wonder, and my humanity. I try to leave something of my own spirit behind, because I am being enriched by the spirit of the person or thing I photograph. We make an exchange. This doesn't happen all the time, but I try for it. When it does, the photographs are wonderful.

There is a responsibility that comes with making photographs, an obligation to the subject and to the pictures that result from our collaboration. This idea was made especially

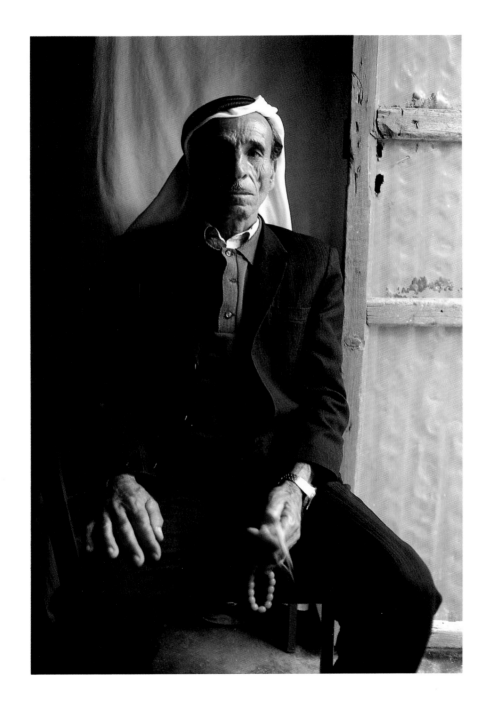

MAN WITH PRAYER BEADS, *Aglun Camp, Jordan.*

clear to me one time when I was working on the Navajo Reservation. Ella, my interpreter, was explaining to a woman that I wanted to take pictures. The woman's husband, who spoke English, told me what Ella had said. "She tells us that you take pictures of the truth and she said it four times, our Navajo way of adding emphasis." Then he said, "You are welcome here. You can take pictures." Now I had to make pictures that were truthful and then use them truthfully. That was my responsibility to the Navajo family and to the people who look at the pictures.

Edward Steichen, the photographer who assembled the famous *Family of Man* exhibit, said, "The mission of photography is to explain man to man and each man to himself." As a documentary photographer, I try to follow this admonition for "concerned photography" by photographing with care, respect, truth, and wonder.

This book includes three sections of photographs: people from Baja California in Mexico, people from Matelot Village in Trinidad, West Indies, and people from Palestine living in Jordan, Lebanon, the West Bank, and the Gaza Strip. On the surface, the three groups seem very different, but in my experience, they are very much the same. What I want to show you are pictures of people. I want you to realize that despite cultural differences, these people are pretty much like people everywhere: they are men, women, fathers, mothers, children, sons, daughters; we all share a common set of emotions, joys, and fears.

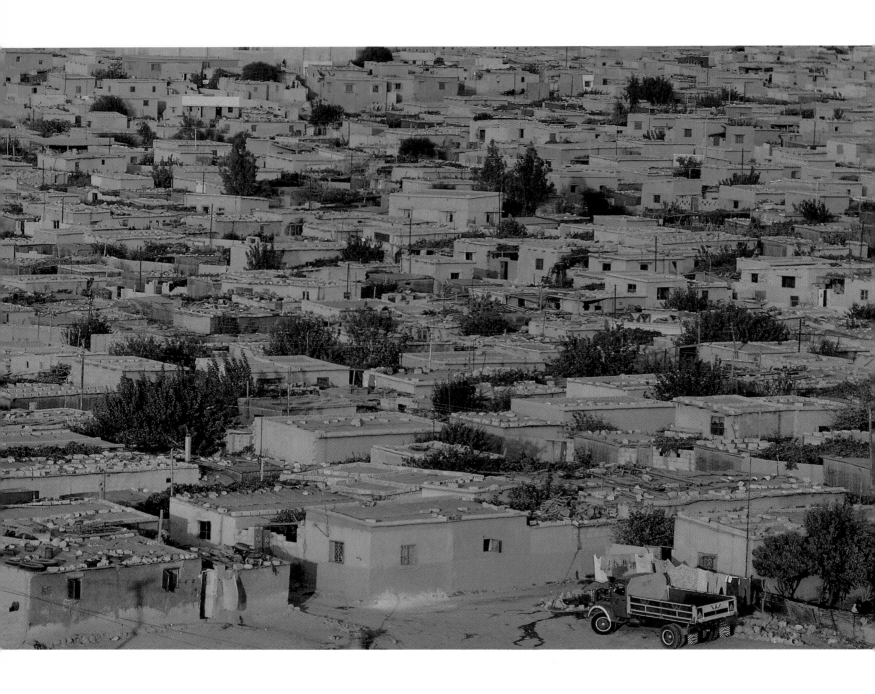

BAQAA CAMP, JORDAN.

Palestine

~~~~~~~~~~~~~~~~~~~~~~~~~~~~~~~~~~~~~~~~~~~~~~~~~~~~~~~~~~~~~~~~

*"The creator's responsibility is a great one;*
*he opens a road that may entice the future*
*and force it to make up its mind."*

NIKOS KAZANTZAKIS, *Report to Greco*

ALESTINE. Palestinians. Who are the people who call themselves Palestinians? They are the people who inhabited the land we call Israel before it was Israel. They are the people who lost their land when the United Nations established a homeland for the Jewish people in 1948. Palestinians are four million people who inhabited what the world was led to believe was an uninhabited desert. The Palestinians are an entire nation of people who were suddenly and forcefully evicted from the land of their birth.

The majority of the Palestinians have been living in exile in other Arab countries. But instead of melding into those populations, they have retained their identity, not as a band of rebels, but as a nation in exile bonded by the memory of a homeland, by a sense of injustice, and by the universal dream of returning to the land they claim by birthright.

I traveled to the Middle East with the goal of meeting the Palestinians and photographing them. I found the Palestinian people not much different from people anywhere. I found men and women with families like any other, with the same basic needs and concerns of people everywhere. I found Palestinians working as teachers, engineers, doctors, lawyers, bankers, shopkeepers, artists, and poets. I found young people dedicated to pursuing an education and striving to do well. I found older people who once planted and harvested the land of Palestine, struggling to provide for their families.

I found that after forty-two years in exile, the Palestinian

7

people still give their hearts to Palestine. Even children born and raised outside their country, when asked where they are from, will reply with the name of their village in Palestine. One friend said, "I carry a Jordanian passport when I travel. But my passport for Palestine is here, in my heart."

What does it mean to say, "I'm from Palestine?" It means that the world labels you a terrorist, when in fact Palestinians are fighting for their homeland much the same as one might expect anyone to defend their homeland. It means that the world believes you are an impoverished refugee, when in fact Palestinians are among the most highly educated people in the Middle East. It means that the world believes you are an invader, when in fact Palestinians have fled the wars and taken refuge in countries all over the world. It means that your story is not told in the world press.

I went to the Middle East with my own funds. I went to see for myself and to learn. I went to find out who the Palestinians are. I went to make pictures and to bring them back and ask you to look.

I want to show you what I learned of the Palestinians. I simply ask you to look at what I saw. I want you to look at the people who say, "I'm from Palestine."

I found myself inspired by the Palestinian people. Their strength and ardent love of their land motivated me to make pictures for them. I make photographs from an advocate's point of view. Really, I find myself inspired by most of the people I photograph. Perhaps that is what I do best: I make pictures for the people I photograph. I make pictures to show you and ask you to look. Look at these people; they are unique like you. Look at these people; they are the same as you.

I was emotionally moved by my work with the Palestinian people; I remember my emotions when I recall my last leaving from the Middle East. Prior to leaving, I had spent the last two weeks with a taxi driver who drove me any place I wanted to go, who never took any pay, not even for gas or

meals. We spent two weeks working together, and he introduced me to all kinds of Palestinian people; I made photographs and took notes. When he told me good-bye, we embraced and kissed each other's cheeks—the Palestinian way. We then shook hands—the American way. As I turned to board my plane, he looked at me and said, "John Running, I may never see you again, but you will be my friend forever."

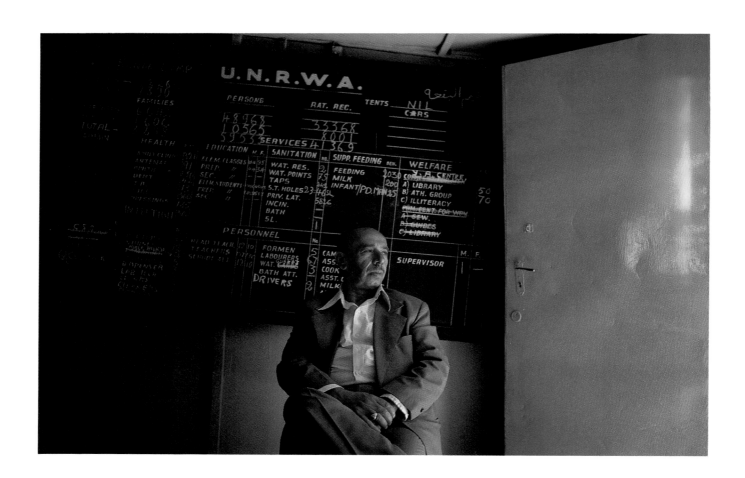

MR. KALIHL, UNRWA HEADQUARTERS, *Baqaa Camp, Jordan.*

*Mr. Kalihl sat behind his desk in the Baqaa Camp office and said, "Tell me. Tell me why the people in the United States will not listen to us. For more than thirty years we have been crying out." He told us, holding back the tears that came to his eyes, that he was forced out of Palestine, and asked that we carry our work back to show the people of the United States.*

(JOURNAL: 10/16/80)

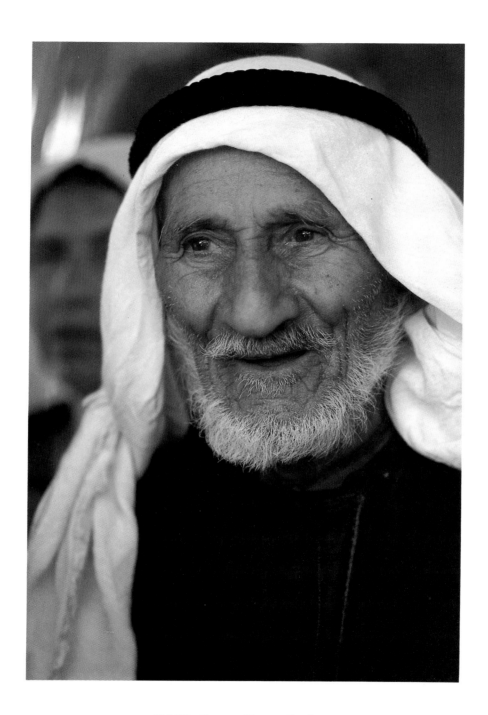

HADJ, *Baqaa Camp, Jordan.*

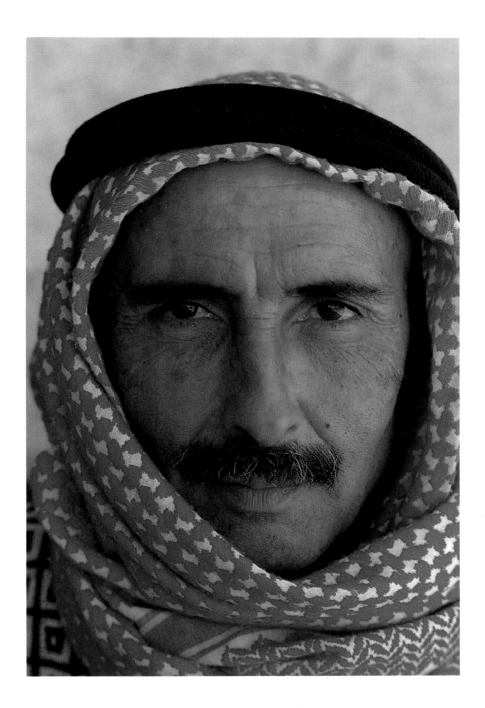

ELIAS, *Ammān, Jordan.*

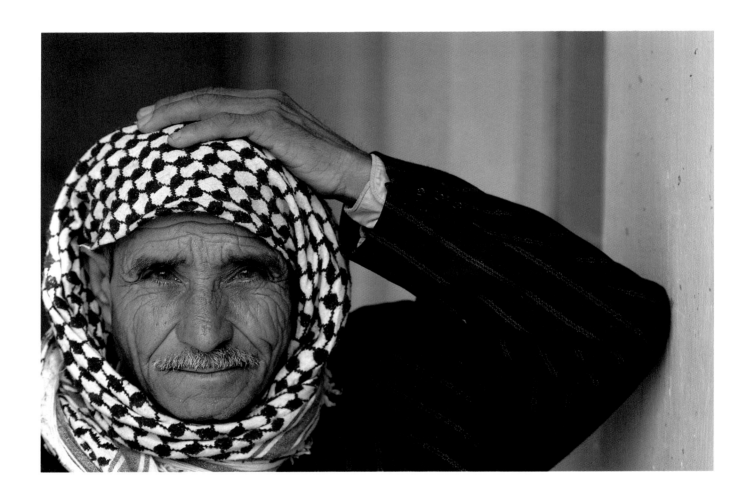

HADJ, *Rashidieh Camp, Lebanon.*

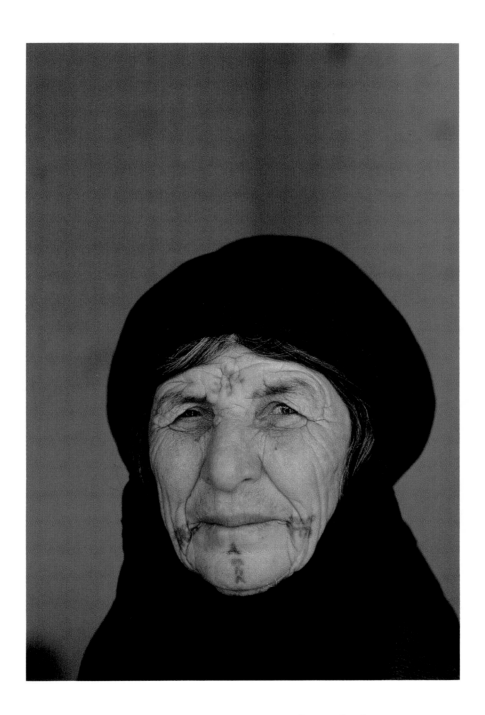

TATTOOED WOMAN, *Baqaa Camp, Jordan.*

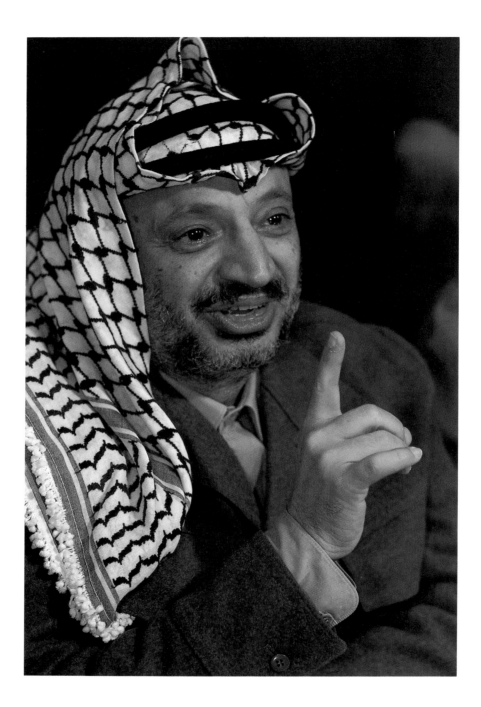

YASSER ARAFAT, *Beirut, Lebanon.*

*Our struggle is not merely*
*a freedom-fighter's gun, but also:*
*the plough of a farmer,*
*the axe of a worker,*
*the transit of an engineer,*
*the book of a teacher,*
*the scalpel of a surgeon,*
*the brush of an artist,*
*the pen of a writer.*

YASSER ARAFAT, *CHAIRMAN*
*Palestine Liberation Organization*

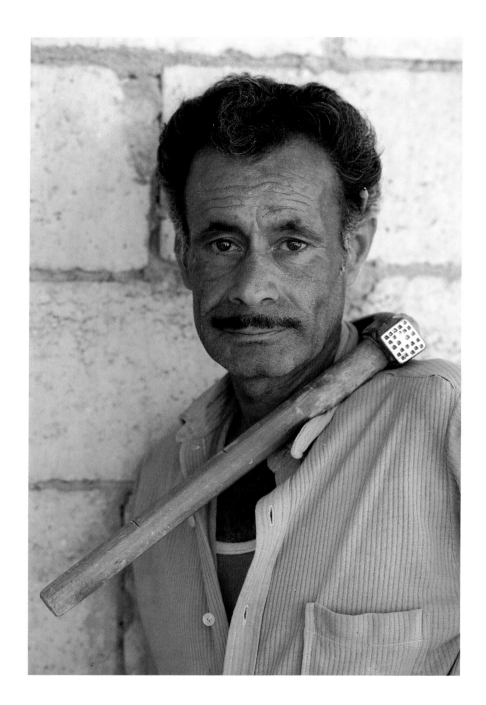

CARPENTER, *Al Hussein Camp, Jordan*.

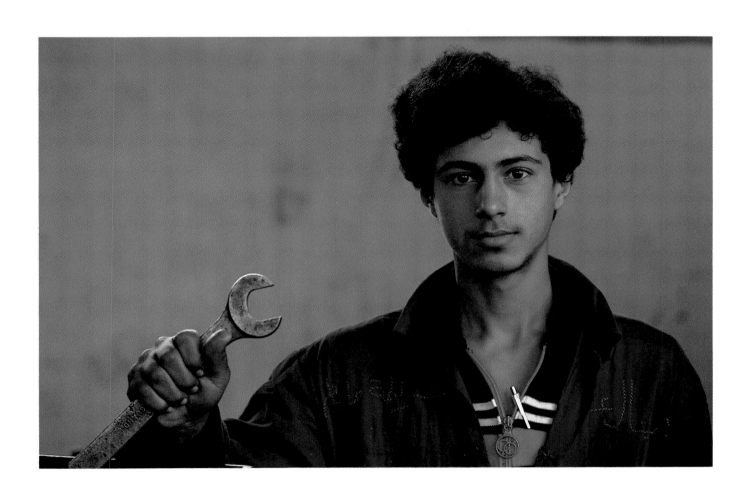

TRADE SCHOOL STUDENT, *Occupied Gaza Strip.*

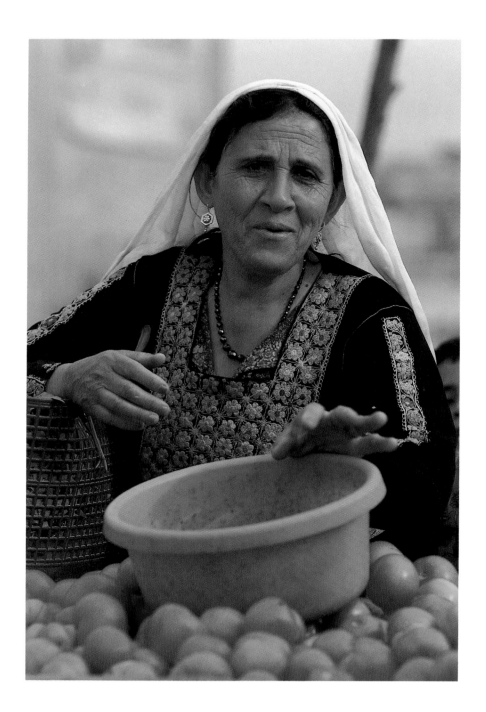

TOMATO SELLER, *Occupied Gaza Strip.*

*Toward the end of the day, I was walking past a planted field adjacent to the camp. A farmer was working there picking vegetables. When he noticed me walking by with my camera bag on my shoulder, he stood up, took a few steps toward me, and stopped to shout, "American! American! Welcome! Welcome! Look, the Statue of Liberty." He stood erect, several heads of cauliflower nestled in his left arm at his waist and one head in the hand of his extended right arm. He stood alone in his field like the Statue of Liberty, a cauliflower representing the torch of freedom, welcoming me to his refugee camp.*

(JOURNAL: 2/8/82)

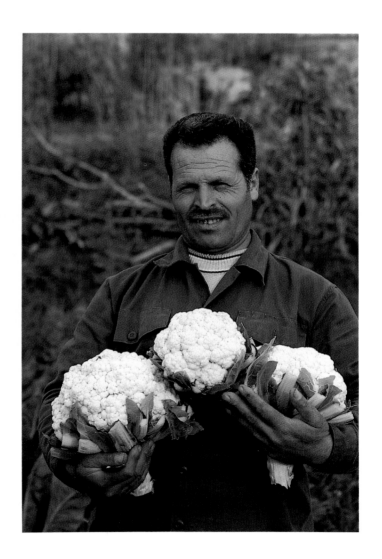

FARMER, *Rashidieh Camp, Lebanon.*

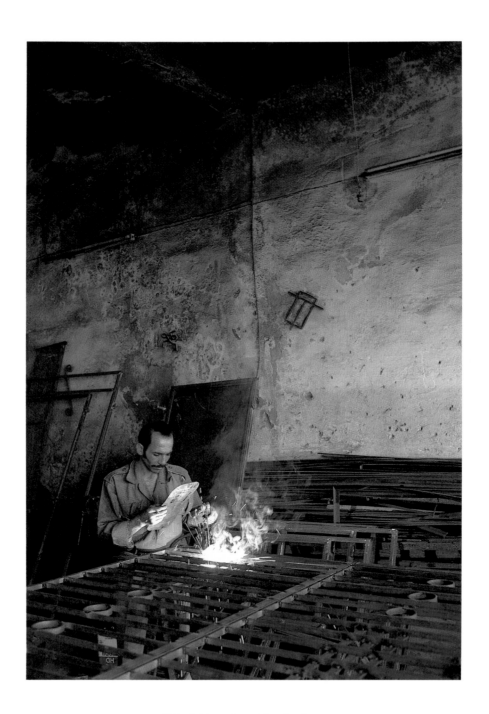

WELDER, *Ammān, Jordan.*

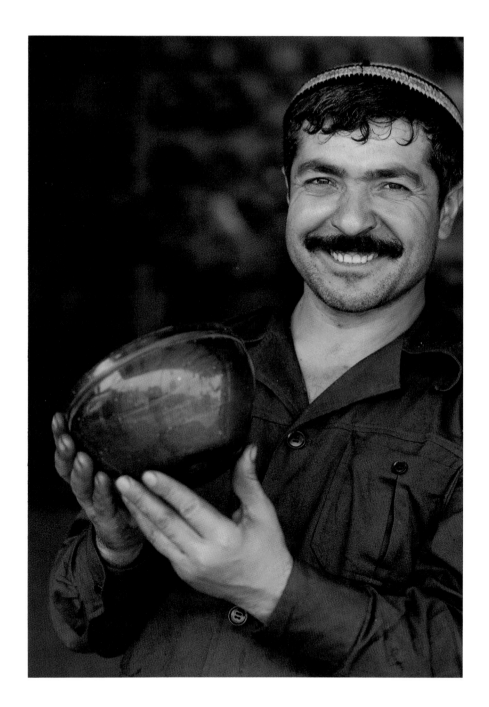

GLASS WORKER, *Hebron, Occupied West Bank.*

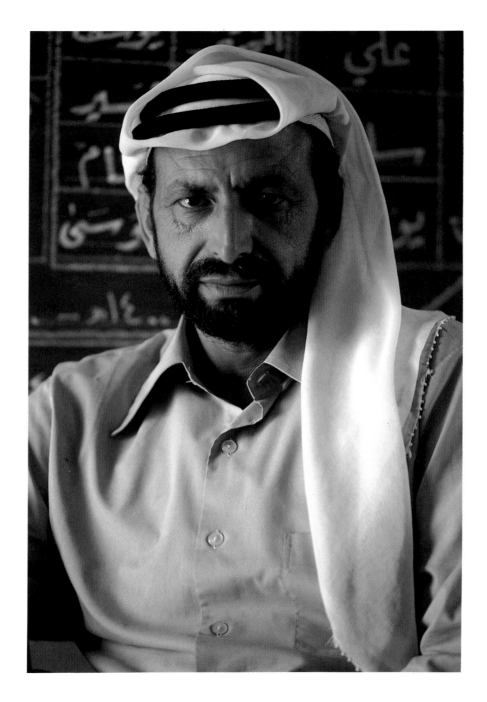

HEADMASTER, BOYS SCHOOL NUMBER 1, *Baqaa Camp, Jordan.*

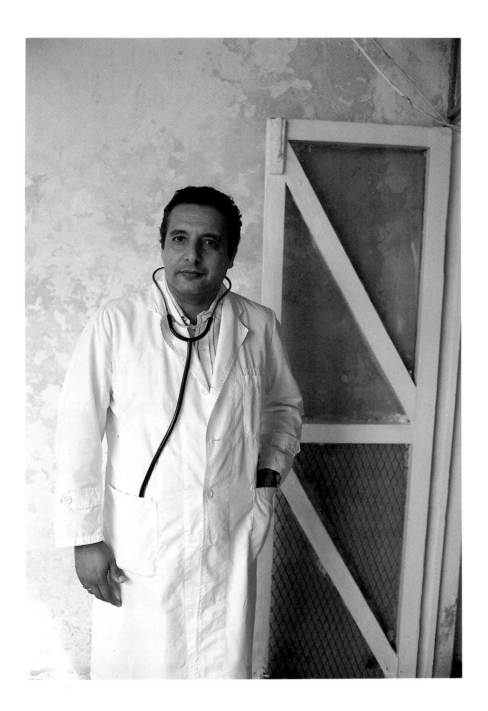

DOCTOR, *Occupied Gaza Strip.*

.

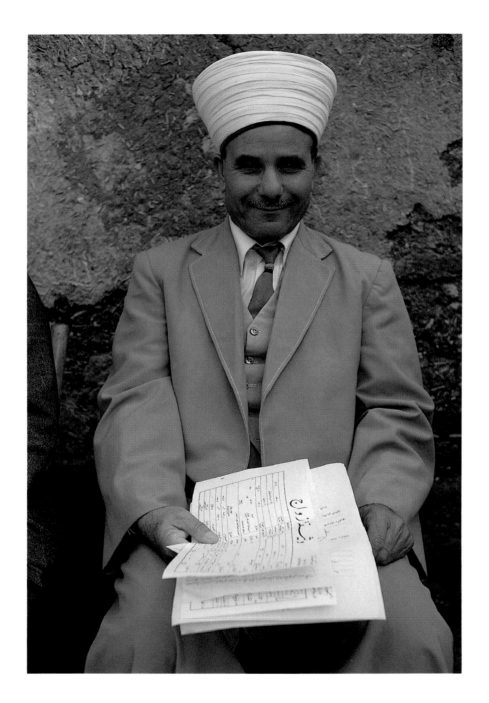

SHEIK AT A WEDDING, *Rashidieh Camp, Lebanon.*

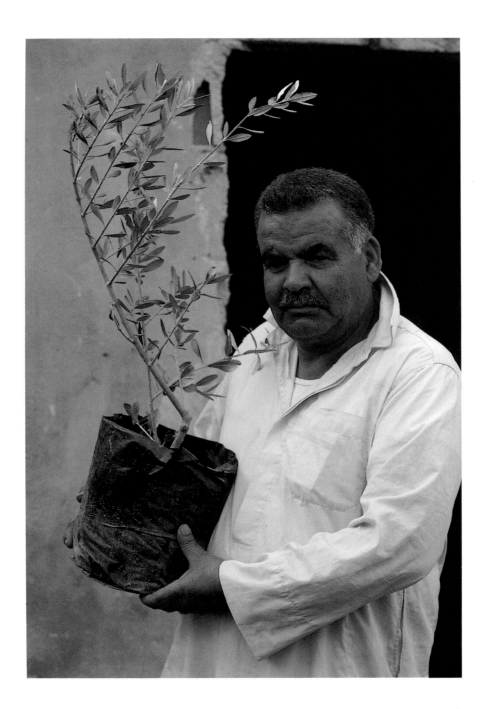

MOHAMMED RAMADAN HAMAD, OLIVE FARMER, *Baqaa Camp, Jordan.*

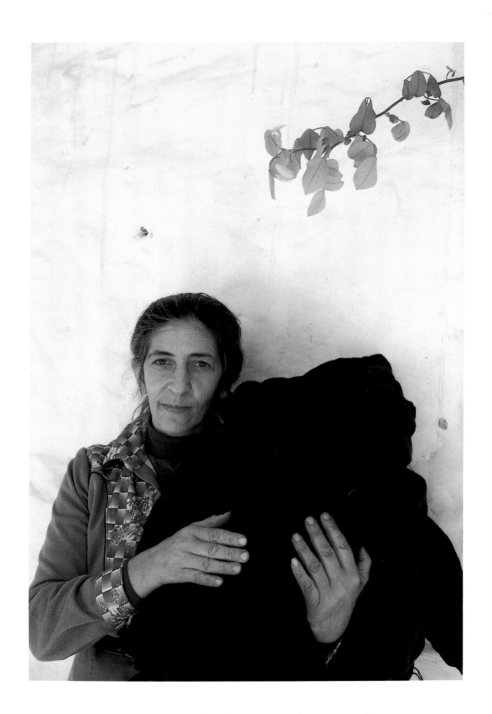

KNITTER, *Al Breh, Occupied West Bank.*

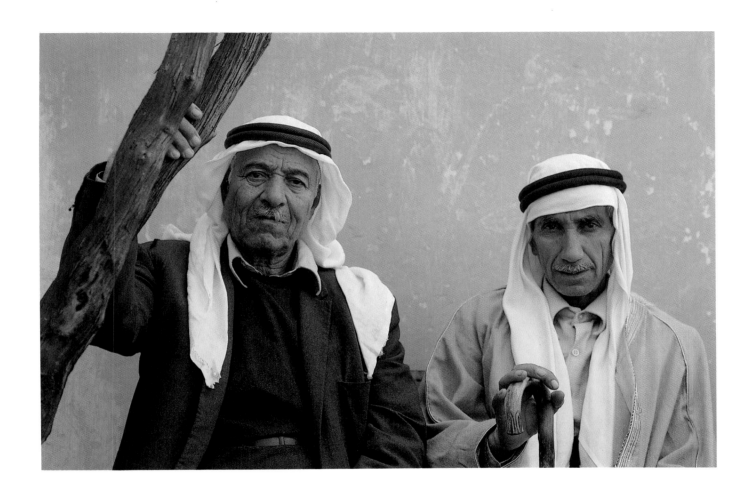

TWO HADJS AT A WEDDING, *Rashidieh Camp, Lebanon.*

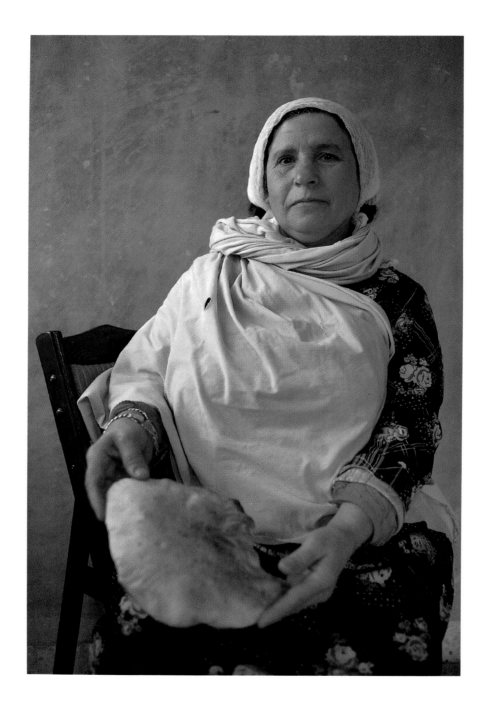

MRS. RADWAN HUDHUD WITH BREAD, *Al Hussein Camp, Jordan.*

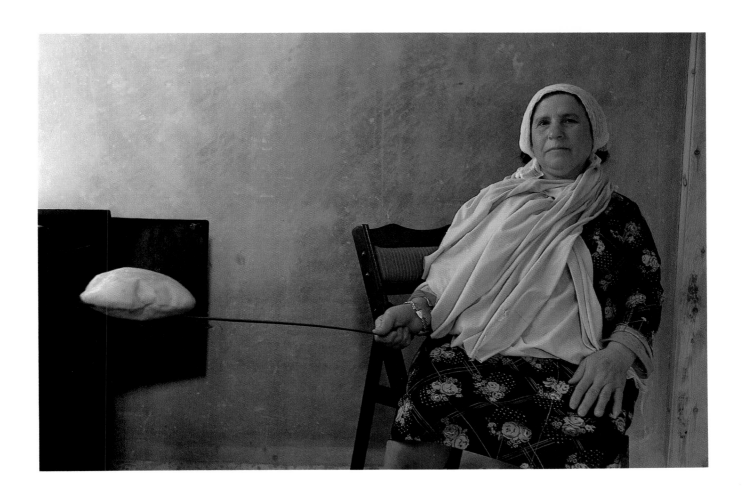

MAKING BREAD, *Al Hussein Camp, Jordan.*

*Ahalain! Ahalain! Welcome! Welcome! Miriam told me. Ahalain is an Arabic welcome. It is difficult to translate, though. Ahalain is really more than welcome; it is a most magnanimous welcome. It means welcome here, this is your home, this is your home after traveling many many miles, where you will be most comfortable and safe from all harm. Ahalain! Miriam told me. I lived in her home for a week, in Rashidieh Camp in the South of Lebanon. After she welcomed me, she showed me around her home: the kitchen, bedroom, bathroom, where I would sleep, and the bomb shelter. "Watch the children," Miriam told me, while I was a guest in her home. "Watch the babies, the twins." They were just three or four years old. She told me to watch them, because the small children had more sensitive ears and always heard artillery planes first and ran for the bomb shelter. By watching them, I would know when to run to the bomb shelter.*

(JOURNAL: 2/7/82)

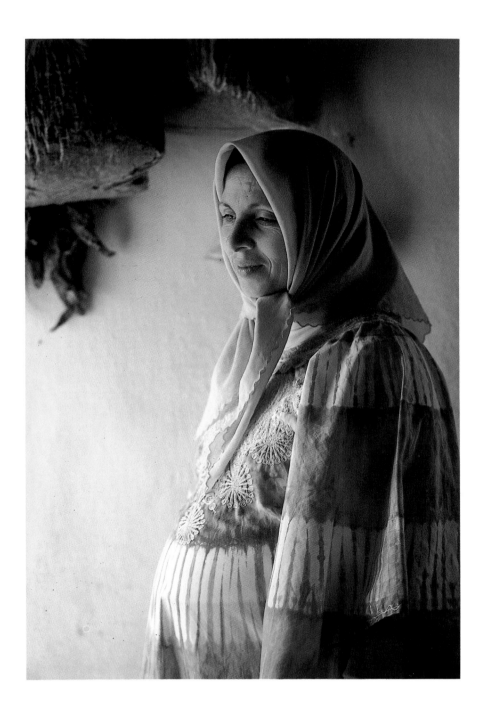

OMM NASER, *Rashidieh Camp, Lebanon.*

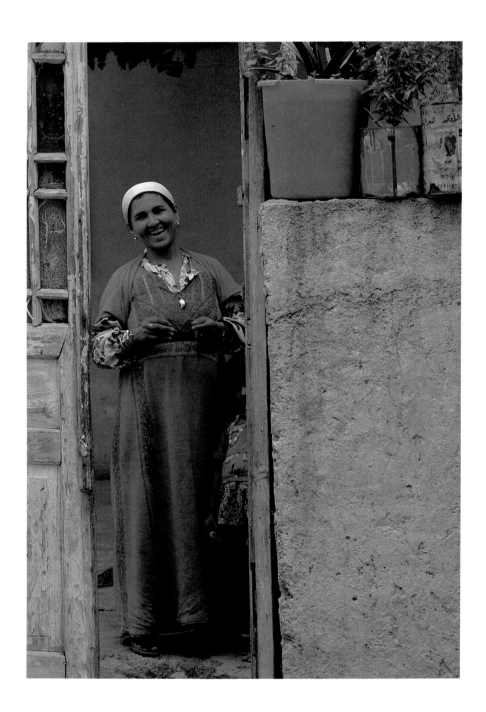

WOMAN AT HER GATE, *Jalazone Camp, Occupied West Bank.*

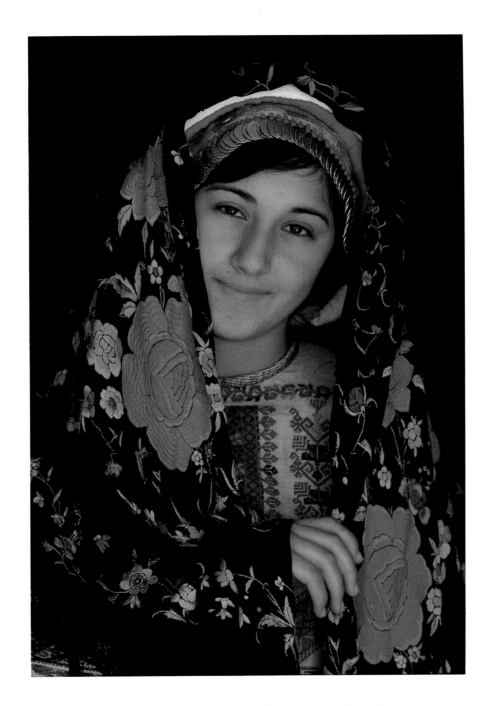

TRADITIONAL DRESS, *Al Breh, Occupied West Bank.*

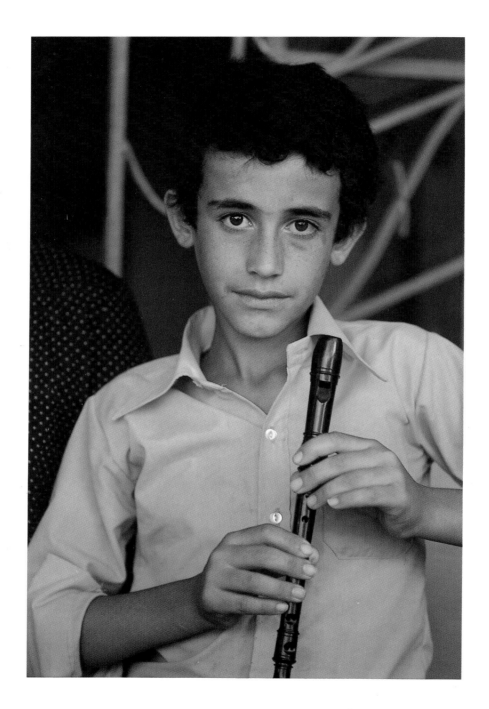

BOY WITH FLUTE, *Baqaa Camp, Jordan.*

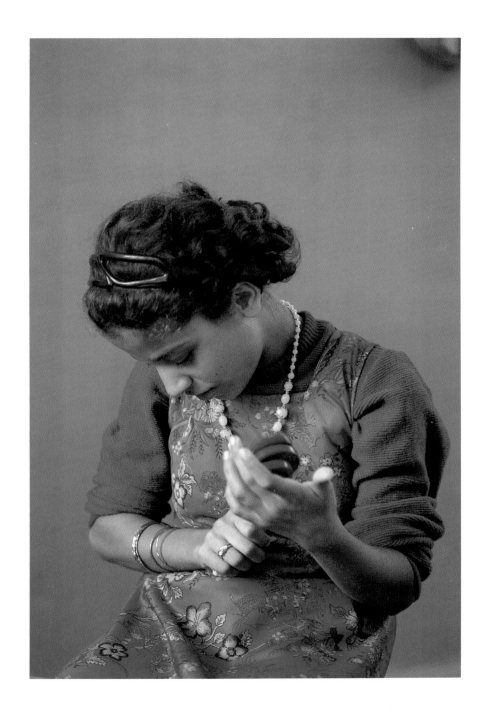

SCHOOL FOR THE BLIND, *Occupied Gaza Strip.*

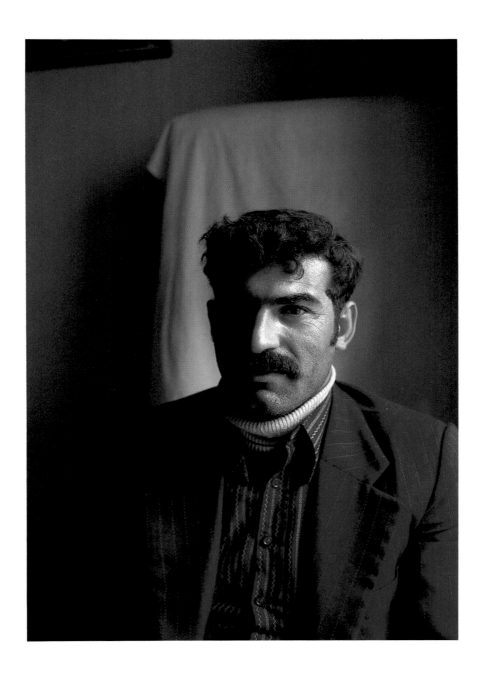

MAN IN DOORWAY, *Aglun Camp, Jordan.*

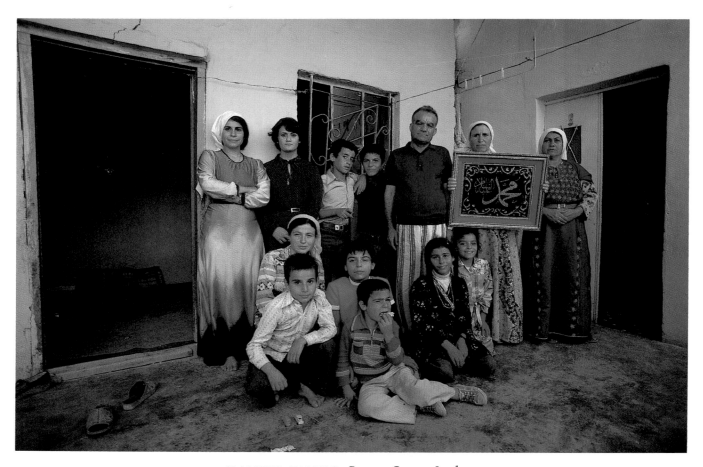

MANSUR FAMILY, *Baqaa Camp, Jordan.*

*Each family in Baqaa camp has been allotted a space that measures ten-by-ten meters, in which a shelter six-by-eight meters may be built. Palestinian families are large. Imagine. Take ten long steps, turn right, take ten more long steps and so on until you complete a square, and then live there with your family for years.*

(JOURNAL: 10/16/80)

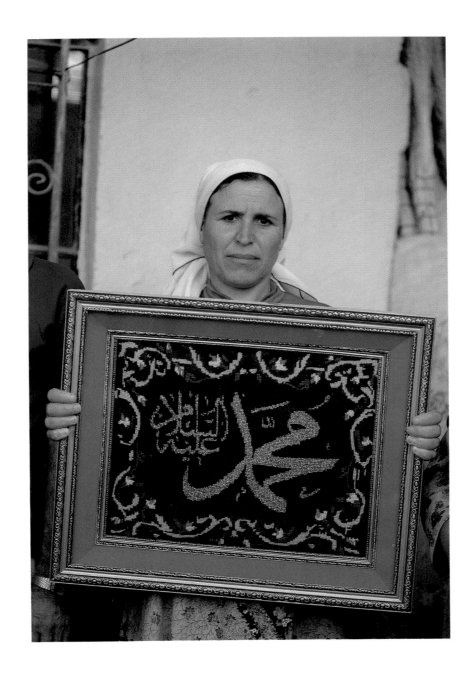

MRS. MANSUR HOLDING THE NAME OF ALLAH, *Baqaa Camp, Jordan.*

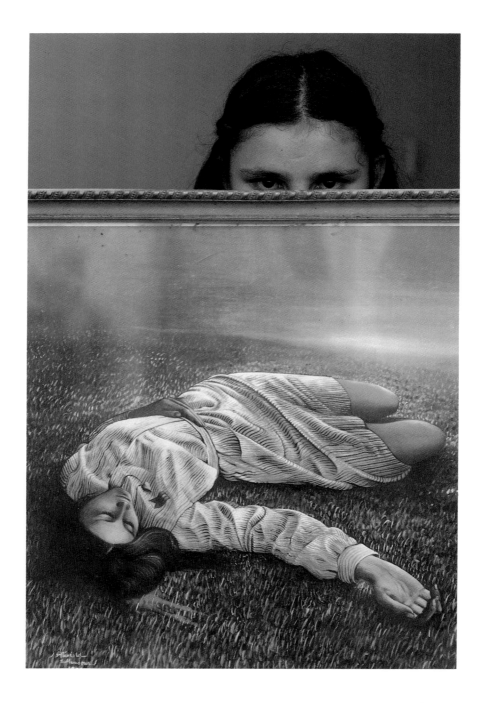

GIRL WITH A PAINTING OF LENA NABULSI, *Ammān, Jordan.*

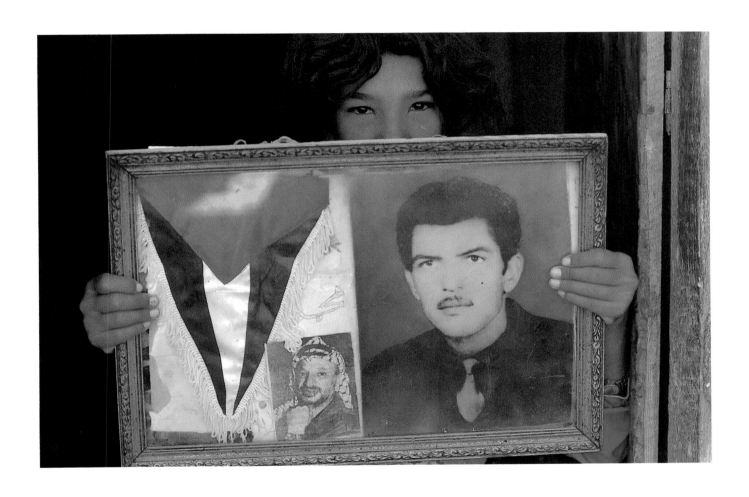

GIRL WITH A PHOTOGRAPH OF HER MARTYRED FATHER, *Ammān, Jordan.*

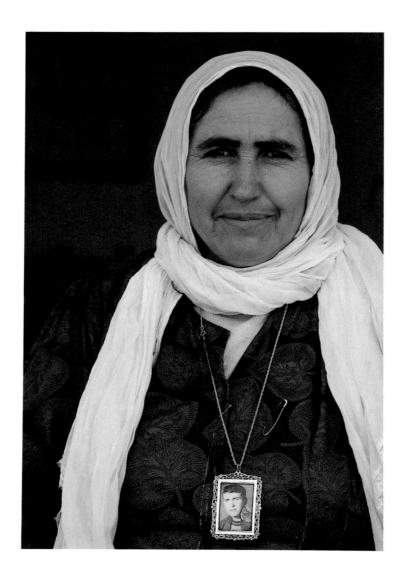

SOFIA RAMADAN OMM MOHAMMED, *Rashidieh Camp, Lebanon.*

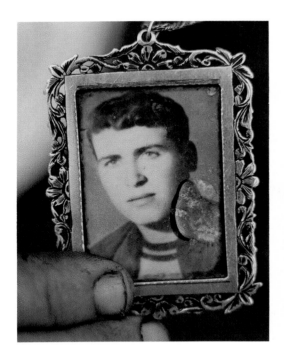 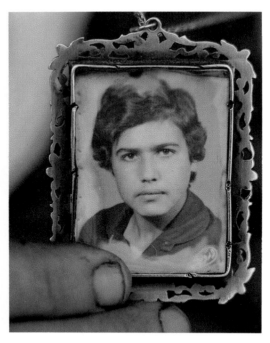

OMM MOHAMMED'S SONS, MOHAMMED (left) AND RADWAN (right), *Rashidieh Camp, Lebanon.*

*Look at Sofia Ramadan Omm Mohammed walking down the road in Rashidieh Camp in the south of Lebanon. She had the appearance of a big woman with a deliberate walk. I noticed the medallion she wore around her neck, a small photograph at the end of a chain. I asked her if it was a picture of her son. She nodded yes. "Could I take a picture of you with your son?" She again nodded yes. I made some pictures and nodded my thanks. Then she turned the locket over and showed me her other son. Both killed. Both died for Palestine. The oldest, Mohammed, was a commando and was 25 when he was killed. Radwan, her youngest, was only 16 when he died in his schoolyard, struck down by an artillery shell just three meters from the bomb shelter. Omm Mohammed was a strong women. She had to be—she carried her two sons around her neck.*

*(JOURNAL: 2/8/82)*

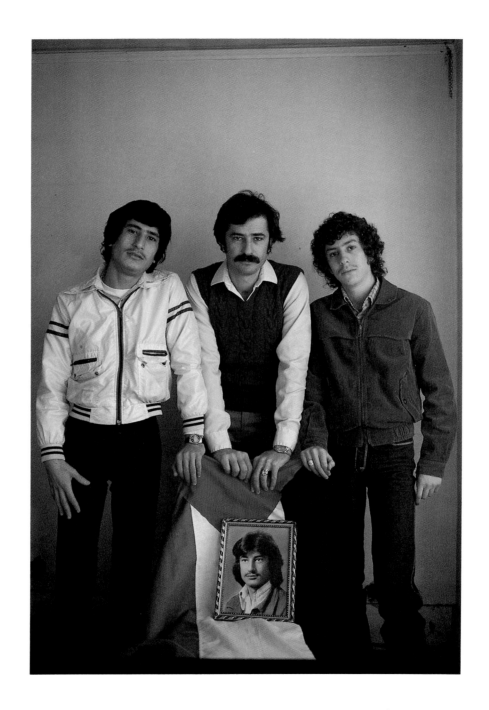

FOUR BROTHERS FROM BURJ-EL-BARAJANEH, *Lebanon*.

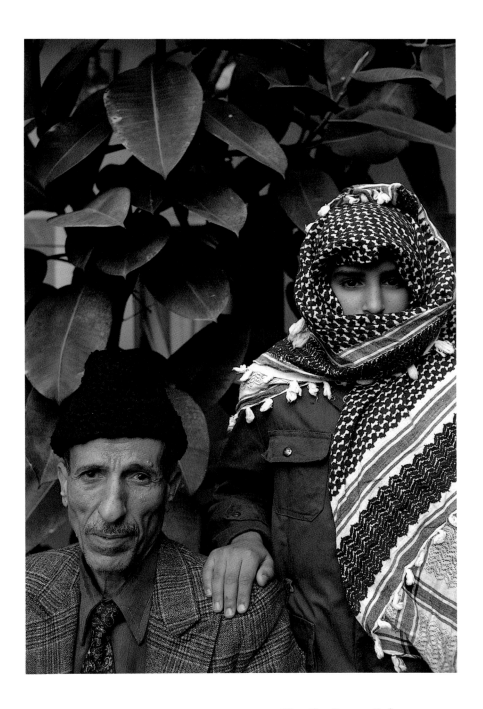

ABO TARIK SALAMEH AND SON, *Shatila Camp, Lebanon.*

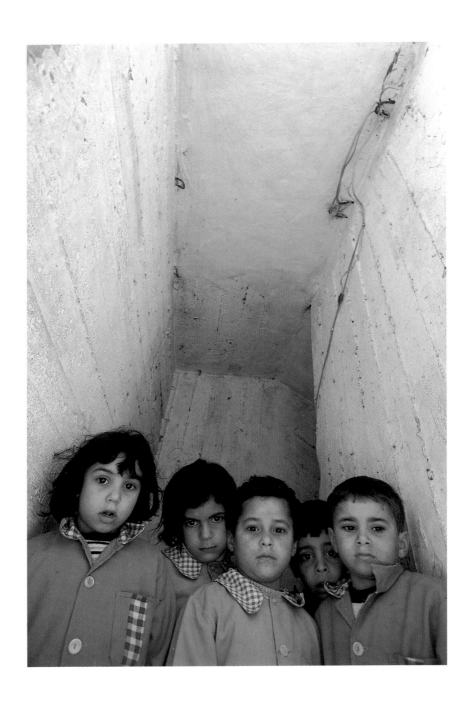

CHILDREN IN BOMB SHELTER, *Rashidieh Camp, Lebanon.*

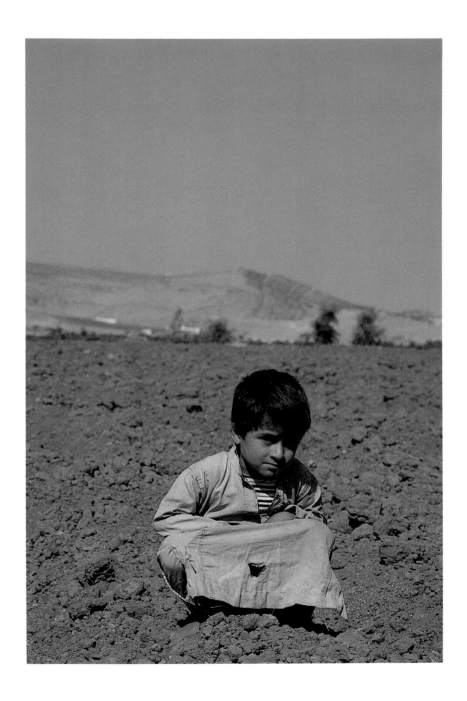

BOY IN A PLOWED FIELD ADJACENT TO BAQAA CAMP, *Jordan*.

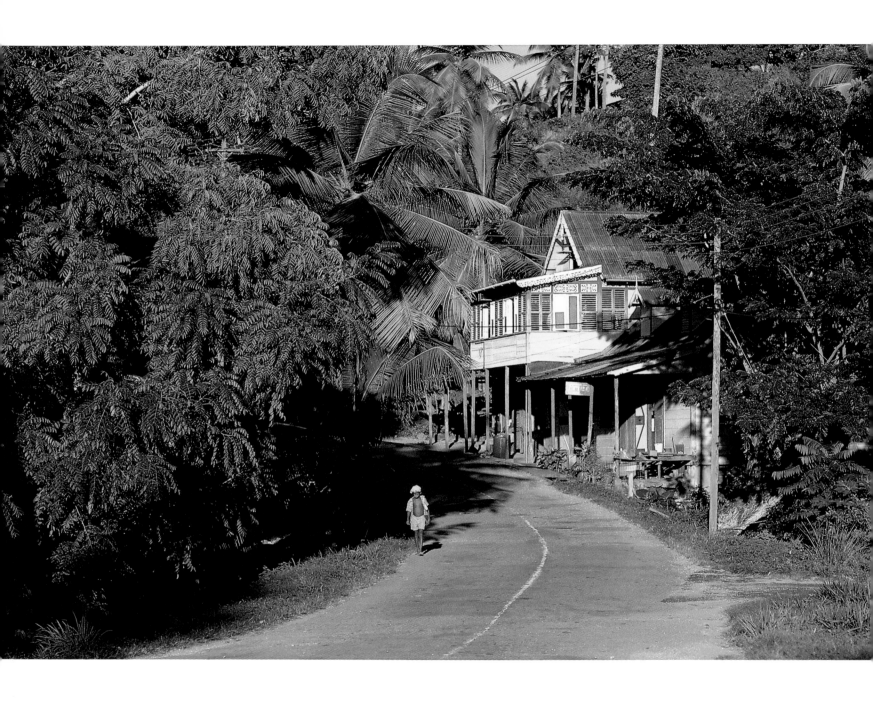

ROAD TO TOCO VILLAGE, *Trinidad, West Indies.*

# Trinidad

~~~~~~~~~~~~~~~~~~~~~~~~~~~~~~~~~~~~~~~~~~~~~~~~~~~~~~~~~~~~~~~~

MATELOT VILLAGE

TRINIDAD IS AN ISLAND NATION at the bottom of the Caribbean, just nine miles off the coast of Venezuela. I was stationed there for eighteen months while I was in the Marine Corps and have been back a few times since to visit family and work on a children's book, *Lester*, one more book in the Children of the Sea series.

The isolated village of Matelot is located on the north coast of Trinidad, out behind God's back. I used to go to Matelot diving and spear-fishing; now I was back to make pictures. I lived in a little house a mile from the main village of about sixty families. On my first day, I met the Salvary family and Lester after going down to the protected little cobble cove people there called the "fishing beach." Each morning the fishermen would come in and haul their catch and boats up for the day. Villagers would gather there to meet the fishermen, help drag in the boats, and buy fresh fish for their large midday meal. The fishing beach was like the town square, the heart of Matelot Village.

On my second day in Matelot, I went to the village's three shops—little tin shed stores—drank a soda, and told the proprietors that I was there to make pictures for a children's book and that I would be hanging about for a couple of weeks. I figured that the news and purpose of my visit would be at least hearsay knowledge within the day. It worked. I walked every place I went, even though I had a car. People greeted me as I walked up or down the road and they brought produce or

fruit to my home or invited me to share a meal. The road and the fishing beach were my keys to Matelot Village.

I often visited in the evenings with Mr. and Mrs. Gludd: we would drink tea or bush cocoa and sometimes eat fried plantain. I photographed them several times. One time I shot some Polaroids, an individual shot of each of them. Mrs. Gludd admired their color and clarity but was especially taken by the image of her husband, who she said was a fine-looking man. She scowled a bit as she examined her own picture and remarked, "Mr. Gludd is looking so admirable, but me, I find I have too much size."

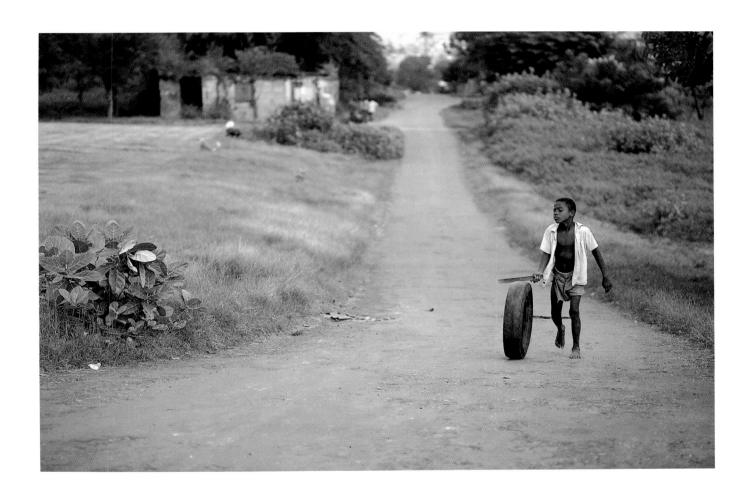

BOY ON TOCO VILLAGE ROAD, *Trinidad, West Indies.*

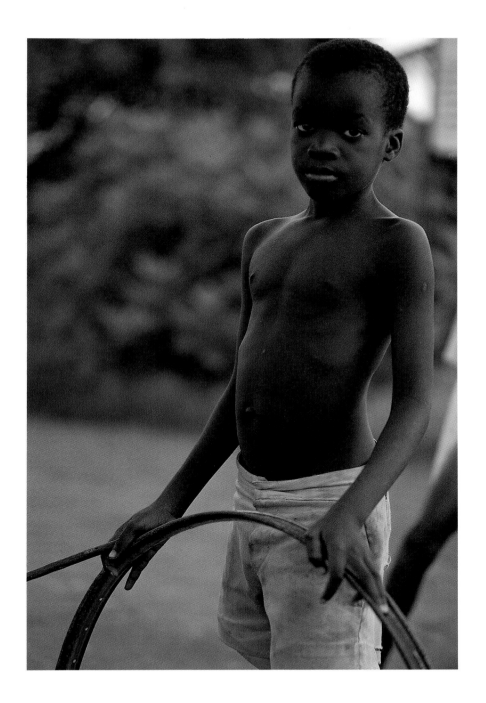

BOY ON TOCO VILLAGE ROAD, *Trinidad, West Indies.*

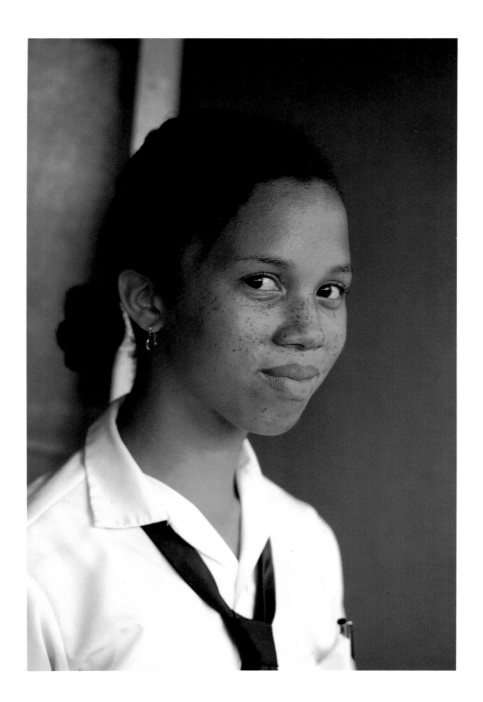

SCHOOL GIRL, *Port of Spain, Trinidad, West Indies.*

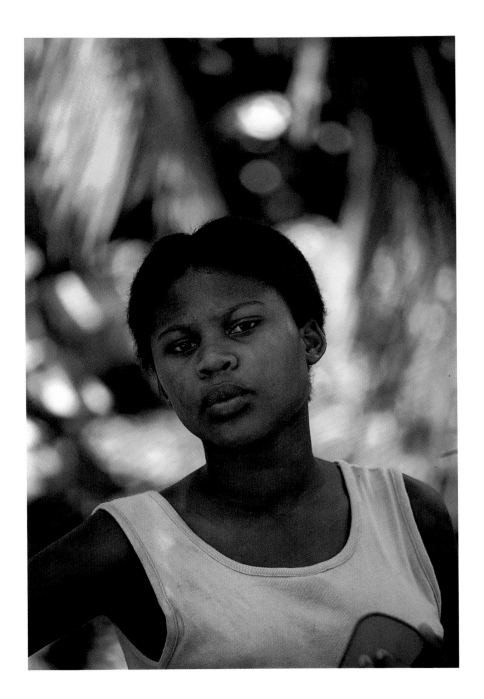

SCHOOL GIRL, *Mayaro, Trinidad, West Indies.*

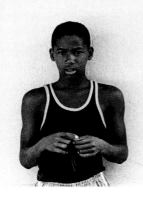

matelot
fishing
co-operative

LESTER, *Matelot Village, Trinidad, West Indies.*

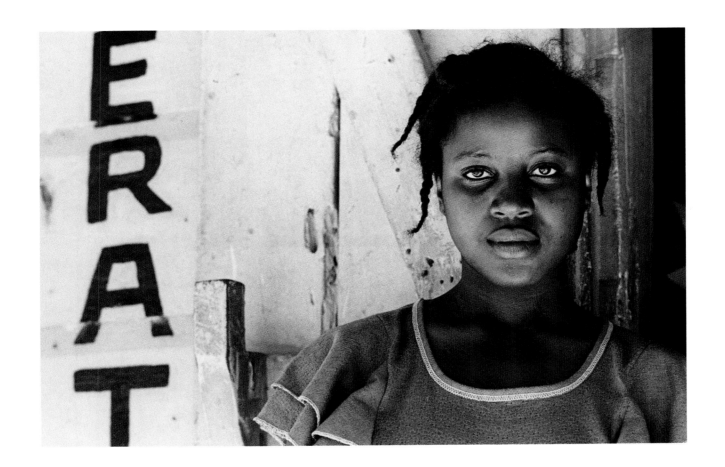

VILLAGER, *Matelot Village, Trinidad, West Indies.*

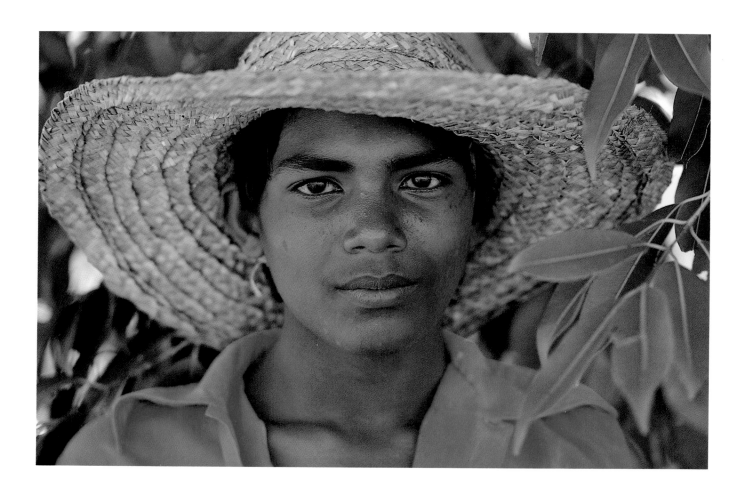

MR. SOMAN'S SON, *Trinidad, West Indies.*

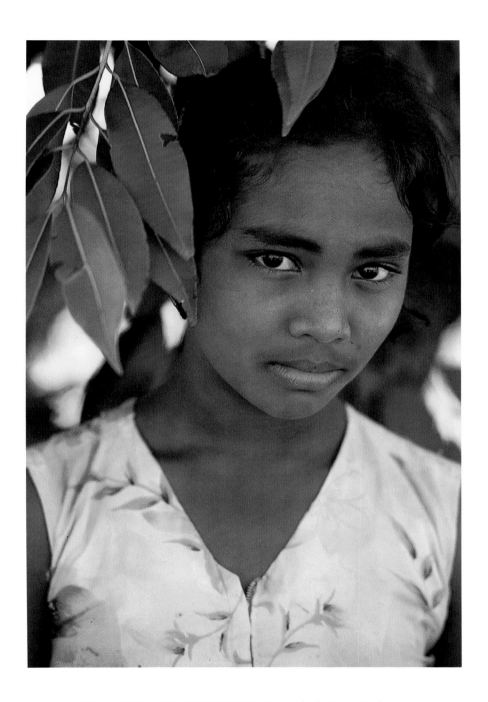

MR. SOMAN'S DAUGHTER, *Trinidad, West Indies*.

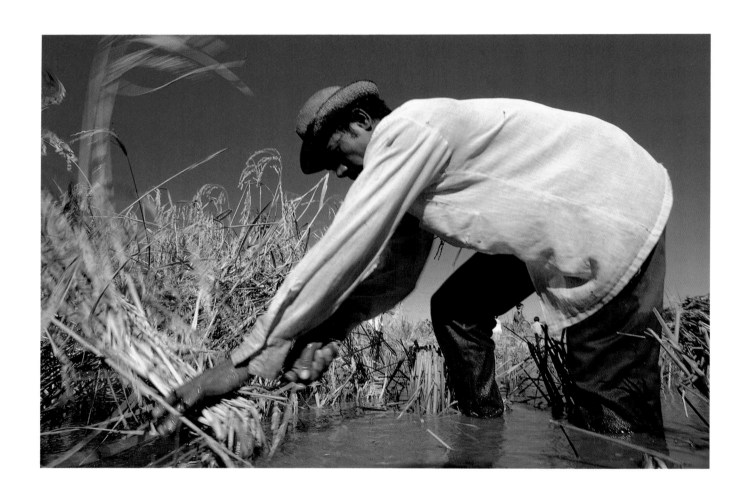

RICE HARVEST, *Trinidad, West Indies.*

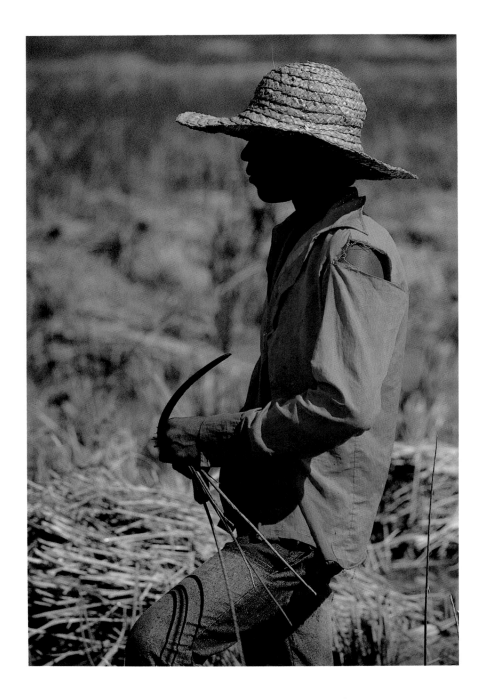

RICE HARVEST, *Trinidad, West Indies.*

Sometimes when you are photographing people extraordinary things happen. I remember photographing Mr. Soman and his family four years ago. They were in the rice paddies harvesting rice by hand, cutting the stalks of grain with a sickle and carrying the cuttings to a dry place on one of the dikes surrounding the paddy. The rice dried there for a few days before they thrashed it by beating it on a slatted table made of sticks. I visited them a couple of times to make photographs. I sent Mr. Soman copies of some of the photographs I had made.

Now four years later, I've returned to Trinidad to shoot photographs for a children's book. I will be here at least a month, but today, in order to get the feel of the place, I decided to visit Mr. Soman and his family to see them and to give them some of the photographs I made nearly four years ago. Mrs. Soman looked at me curiously and then recognized me after seeing the pictures I had in my hand. She invited me into the cool shade of her house for some sorrel drink. Mr. Soman was on an errand and would return soon. I waited. He returned within half an hour or so, walking alongside a water buffalo pulling a cart loaded with bags of cement and concrete blocks; the Somans were enlarging their house to accommodate newly married children. Mr. Soman squinted his eyes toward me, he couldn't see from the bright sun into the shade. We shook hands; I showed him a couple of pictures, and soon there was a smile of recognition in his eyes. He reached up, took me gently by the shoulders, put his head on my chest, and said, "You came back! You came back! No man has ever come back for me. You came back!" We spent the rest of the afternoon drinking sorrel, spicing it with rum, and eating curry and rice. I made a portrait of his youngest son, a cricket player they called Baby Soman.

(JOURNAL: 3/3/76)

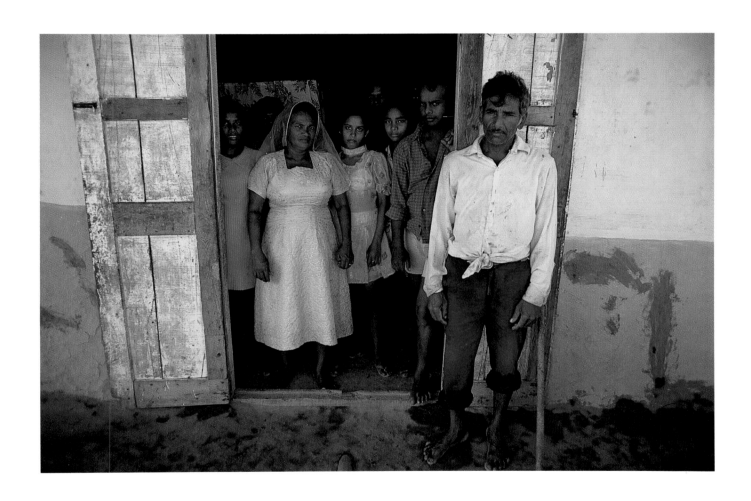

MR. SOMAN WITH HIS FAMILY, *Trinidad, West Indies.*

RICE HARVEST, *Trinidad, West Indies*.

67

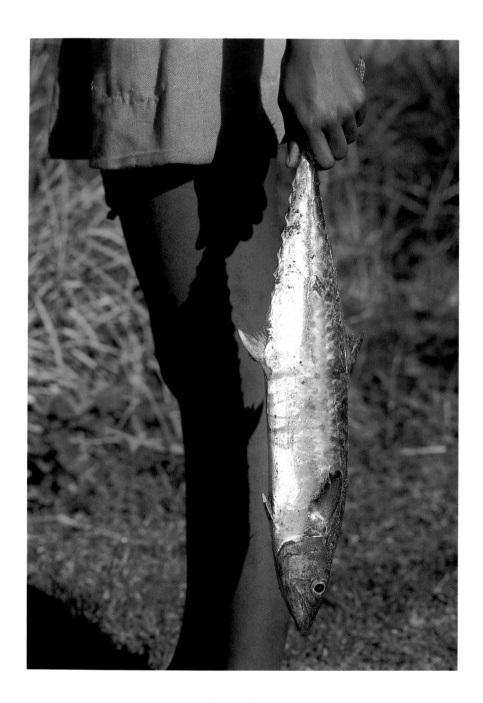

FISHING BEACH, *Matelot Village, Trinidad, West Indies.*

I wake up each morning, make coffee, grab my cameras, and go down to the fishing beach. It was different this morning, and I didn't make any pictures. The seas were especially rough. The men on the beach didn't know why; the winds weren't blowing more than usual but there were big swells coming in from the east. Someone suggested that maybe there was a big storm in the Altantic. In any case, no one caught any fish, and hauling the boats ashore was difficult and dangerous. One by one the fishermen would catch a wave with their boat, ride it into the beach, and we would try to catch it without being dragged back out to sea. Usually someone caught the anchor line and snubbed it around a tree and it would hold. The line snapped on the last boat though. I was holding on the gunnels of the boat and had good footing on the rocky shore. An instant later I was kicking water trying to hang on and not get carried under the boat. Lester's father grabbed my arms and pulled me into the boat. Two waves later we tried again, this time someone threw a line from shore. I caught it, snubbed it on a brass cleat in the bow, and we held. Soaked but safely ashore, I thanked John for pulling me into the boat. Then he gave me this canny smile and invited me to the house tonight to hear his story about when his boat capsized at sea during Hurricane Flora.

(JOURNAL: 3/18/76)

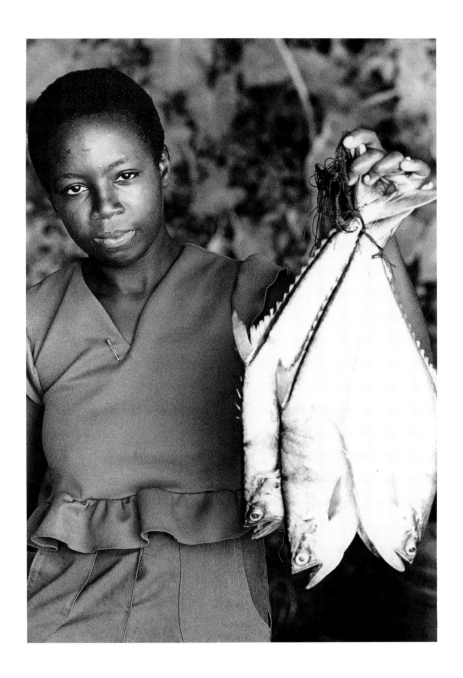

FISHING BEACH, *Matelot Village, Trinidad, West Indies.*

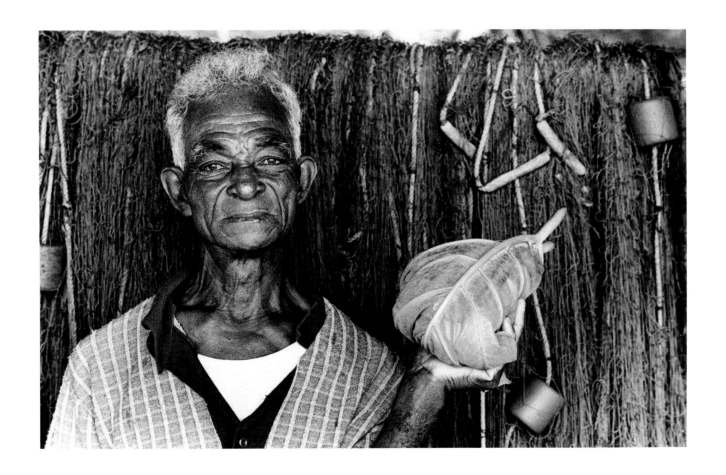

FISHING BEACH, *Matelot Village, Trinidad, West Indies.*

COCOA SHED, *Matelot Village, Trinidad, West Indies.*

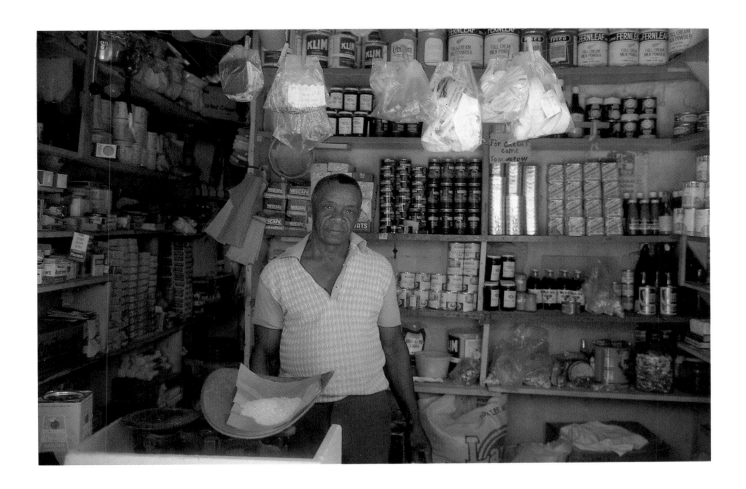

LOCAL SHOP, *Matelot Village, Trinidad, West Indies.*

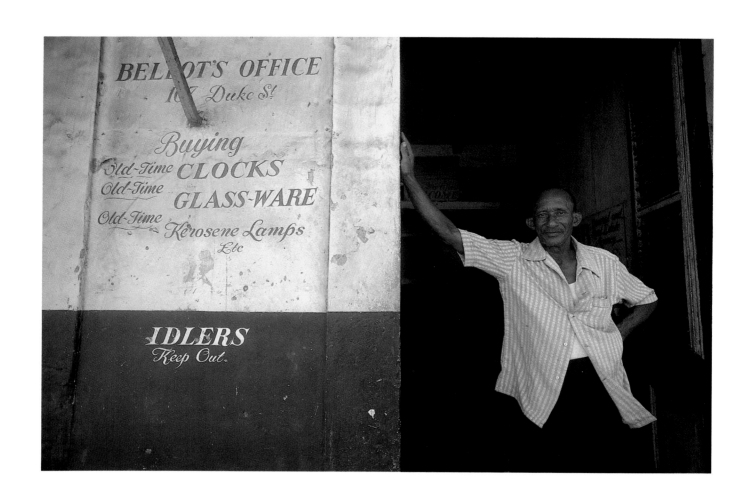

MR. BELLOT, PIANO TUNER, *Port of Spain, Trinidad, West Indies.*

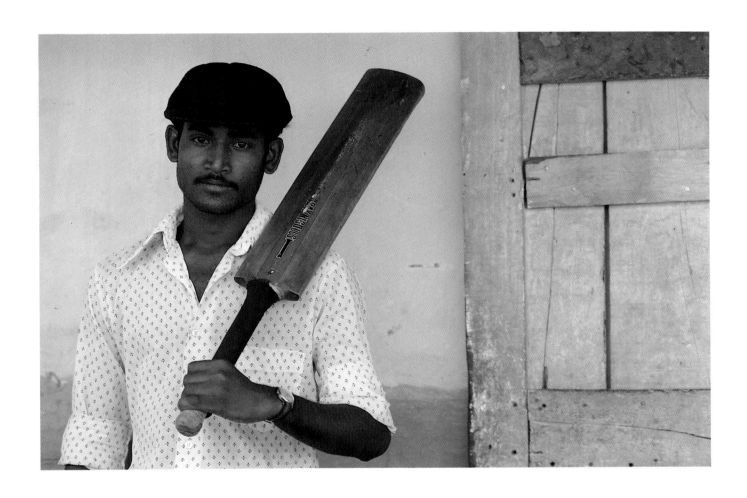

BABY SOMAN, *Trinidad, West Indies.*

MRS. FINDLEY, *Matelot Village, Trinidad, West Indies.*

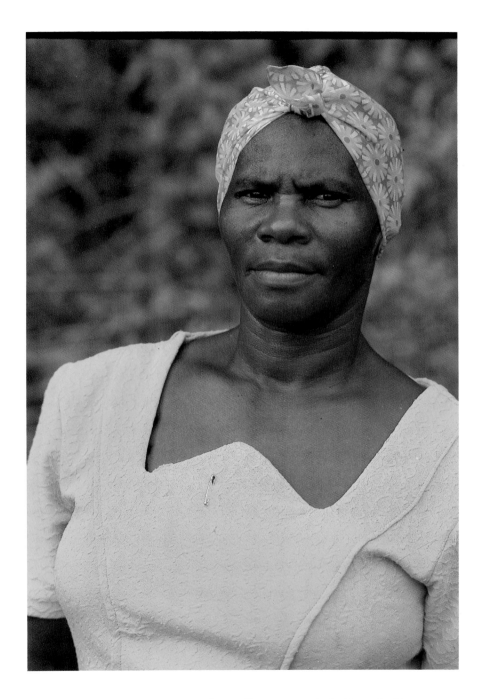

MRS. FINDLEY, *Matelot Village, Trinidad, West Indies.*

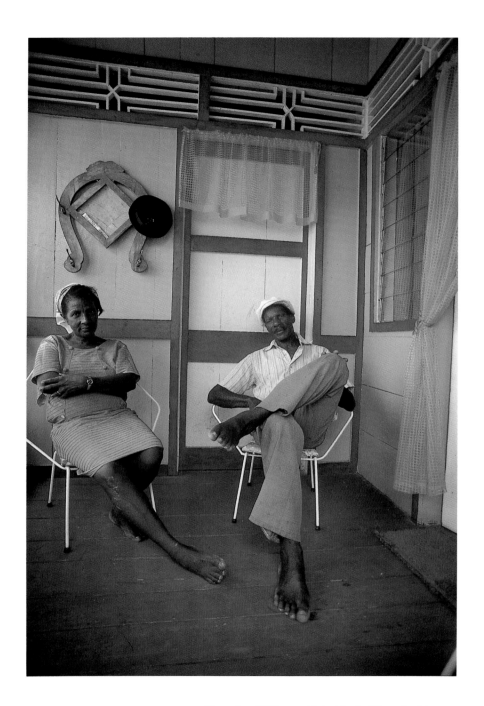

MR. AND MRS. GLUDD, *Matelot Village, Trinidad, West Indies.*

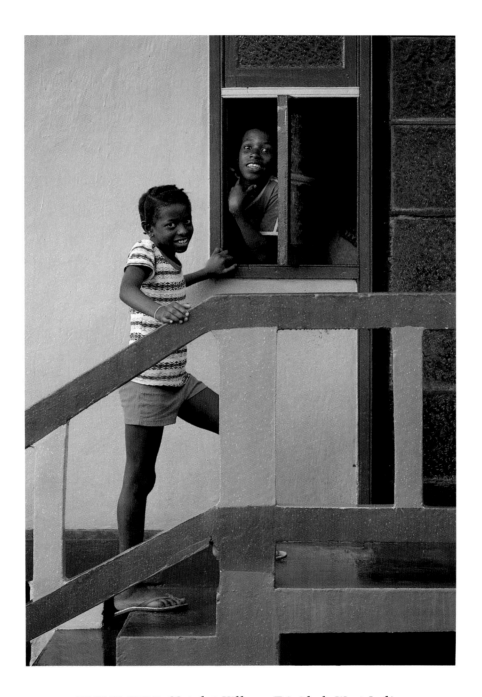

FRONT STEP, *Matelot Village, Trinidad, West Indies.*

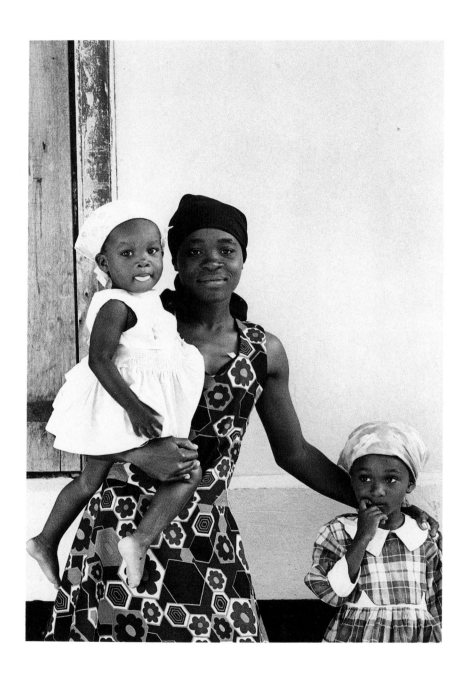

GLORIA WITH HER TWO DAUGHTERS, *Matelot Village, Trinidad, West Indies.*

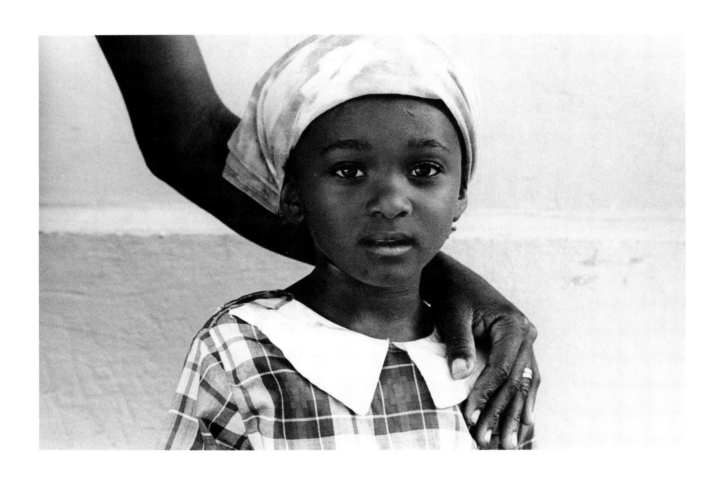

GLORIA WITH HER OLDER DAUGHTER, *Matelot Village, Trinidad, West Indies.*

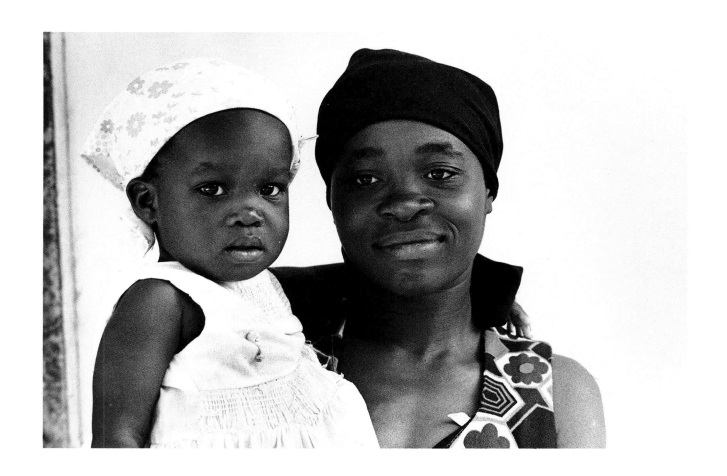

GLORIA WITH HER YOUNGER DAUGHTER, *Matelot Village, Trinidad, West Indies.*

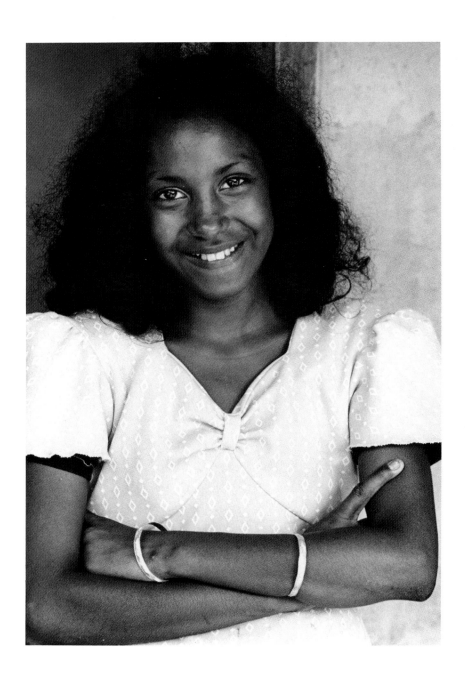

VILLAGE GIRL, *Matelot Village, Trinidad, West Indies.*

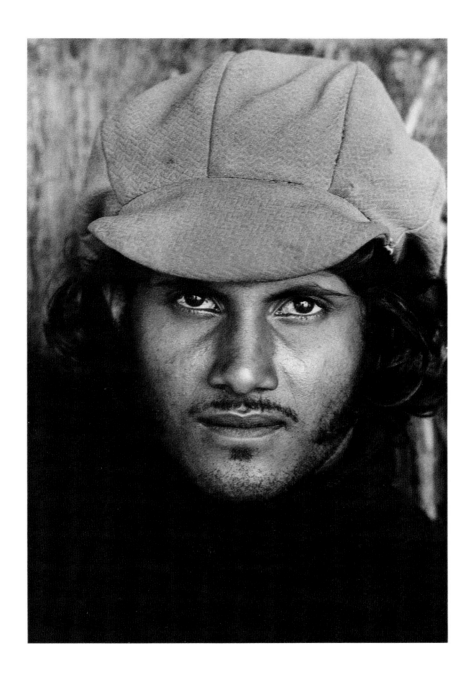

TAHEED, A FISHERMAN, *Matelot Village, Trinidad, West Indies.*

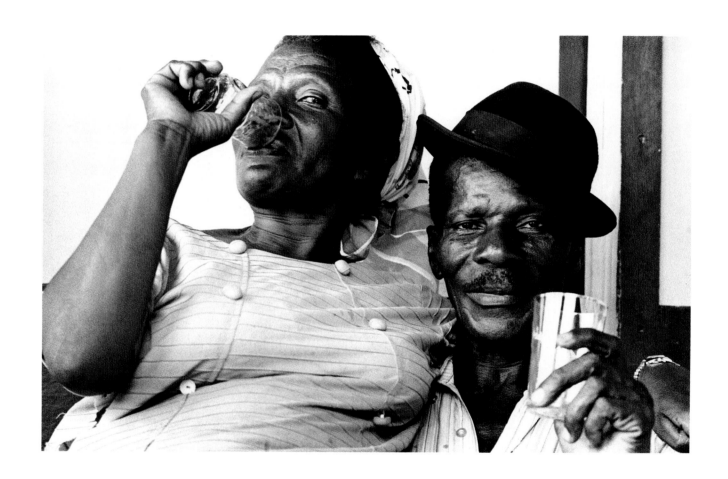

MR. AND MRS. GLUDD, *Matelot Village, Trinidad, West Indies.*

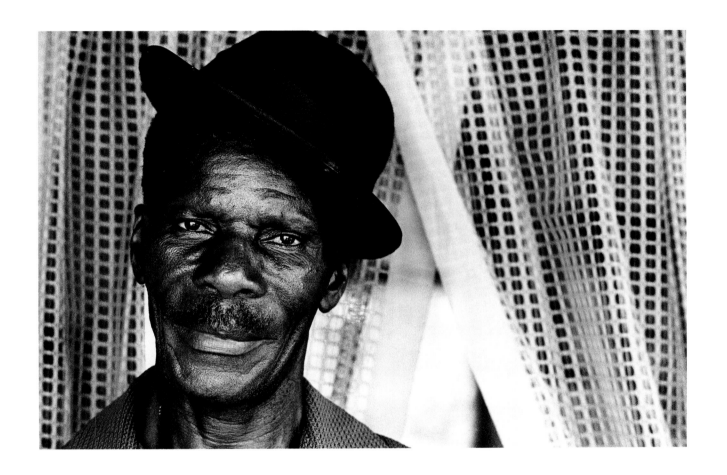

MR. GLUDD, *Matelot Village, Trinidad, West Indies.*

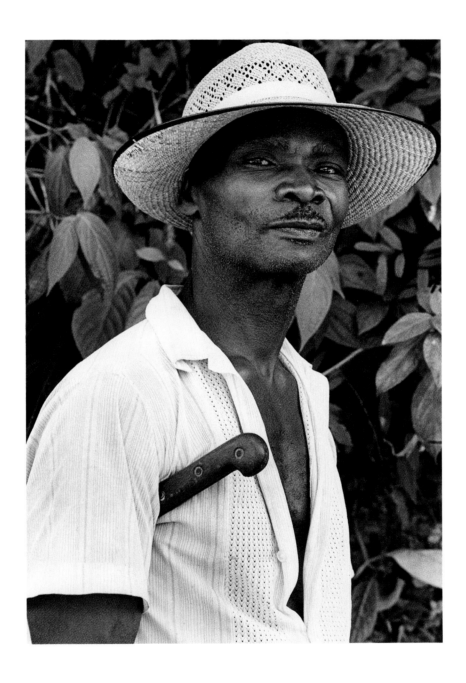

MAN ON THE MATELOT ROAD, *Matelot Village, Trinidad, West Indies.*

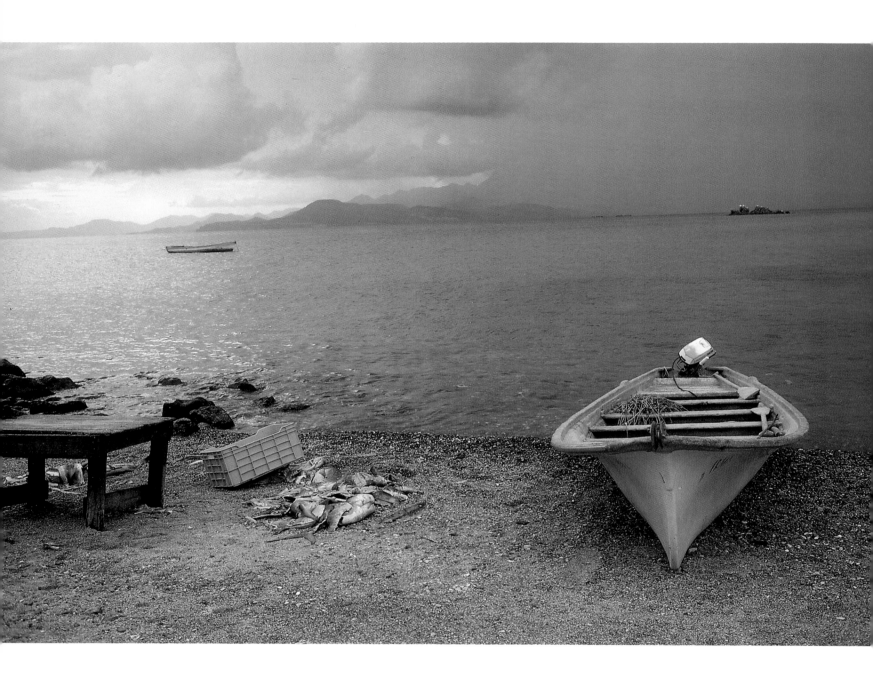

ISLA PARDITO, *Mexico*.

Mexico

~~~~~~~~~~~~~~~~~~~~~~~~~~~~~~~~~~~~~~~~~~~~~~~~~~~~~~~~~~~~~~~~~~~~~~

OME YEARS AGO I was exploring a miles-long beach midway down the east coast of the peninsula of Baja California. A small path through palm trees led me off the beach, past a corn field to a little rancheria. Beauty and curiosity led me on. A tall man in his fifties left the shade of the little house and waved to me. *"Quieres agua?"* he asked. *"Si, por favor,"* I replied. We exchanged greetings and returned to the shade to visit. The light was beautiful: warmed by the hot sun reflecting off reddish earth, opening up the shadows in our cool shade.

I wanted to make pictures of Solomon and his wife, Anastasia. She looked down shyly, and he nodded when I asked permission. First I took some instant pictures with a Polaroid SX-70 camera, then photographed with my 35mm camera. Solomon and Anastasia sat patiently as I worked. I motioned for them to move one way or another, bring a hand up on the arm of a chair, tilt a head up or down. "Would you mind moving over by the door? *Que bonita!* That's beautiful!" We hardly talked at all during the time I shot several rolls of film.

We looked at the SX-70s, the *instantaneas*. Anastasia thought they were beautiful *recuerdos*. I told them that they were for them to keep. Solomon thanked me and told me they had nothing to give me, when Anastasia went into the house and came out with a goat cheese about the size of two clasped hands. "Here, this is for you."

We all sensed that next awkward moment, the time to say *adios*. I had to meet the people I was traveling with back on the beach. I started to say goodbye, when Solomon interrupted, *"Momentito.* A little minute, before you go. Let me take your picture with the *instantanea.* You are taking part of us with you. You should leave something of yourself behind with us. We want to remember you, too."

Solomon took the camera in his fisherman hands, pressed the little red button to make his pictures, telling me to sit there, motioning me to raise or lower my chin. He made several pictures. We waited for them to develop and then agreed, before he slipped them into his shirt pocket, that I looked very good. I held Anastasia's hands for a moment, embraced Solomon, turned from the shade, and headed down the path through the palms and back to the beach. On my way, I thought about how lucky I was to be able to travel, how fortunate I was to meet people like Solomon and Anastasia, how lucky to receive the most personal of all gifts when someone allows me to take their picture and presents me with the gift of their image.

As I walked, I also thought about the lesson Solomon, the wise fisherman, had just given me. "Leave part of yourself behind." When I make pictures, I try to open myself up to the person I photograph. I try to make an exchange. It is necessary if my pictures are going to work at all. It is absolutely necessary. I have to leave something of myself behind.

I have given Polaroid pictures away all over the world. Sometimes when I make an exceptionally beautiful "roid," I am tempted to keep it for my journal. If I have enough film, I'll make two or three and then let the people choose which ones they want to keep. Sometimes I hate to let them go. But I console myself knowing I have my film, I have their gift rolled up in a little cassette. Occasionally, people ask me if they can take my picture, and I think of Solomon and remember. Leaving my picture with the people I photograph is not as important as leaving my spirit with them. Solomon and I communicated with each other, shared our feelings,

and exchanged our humanity. He taught me to make the same exchange with everyone I photograph.

## ISLA PARDITO

I had the opportunity to apply the lessons I learned from Solomon just a few months later. I was assigned to make the photographs for another children's book in the series Children of the Sea. The book is titled *Gilberto* after the twelve-year-old boy featured in the documentary.

My friend Tim Means, the owner of Baja Expeditions, told me about a fishing family living on the remote three-acre island of Pardito. They sounded perfect. It took us a day and a half to get there from La Paz. We arrived late in the morning, and when I explained to Jose Cuevas-Amador that I wanted to make some pictures, he replied, "No problem, you can take my picture." He pulled himself a little more erect for his portrait. I explained further that I wanted to spend about ten days with them to photograph the way he and his family live and work, so he relaxed from his pose, smiled, and said, "Oh you have plenty of time then. Come eat lunch, you can take pictures later."

With that, Tim said that he'd leave me there for a week, after which time I could intercept and catch a ride back to La Paz on one of his southward trips down the Baja coast. I spent the next ten days with the Cuevas family, living and working at their pace on a schedule determined by the sea, the weather, and the amount of fish we caught. I often found myself putting my camera down to help with the physical labor of moving boats, hauling nets, or cleaning fish, which helped me understand more about fishing and ultimately helped me make better pictures. We became good friends during those days—we still are, and I've been back twice. Now Jose and I tease each other about who has the most gray hair.

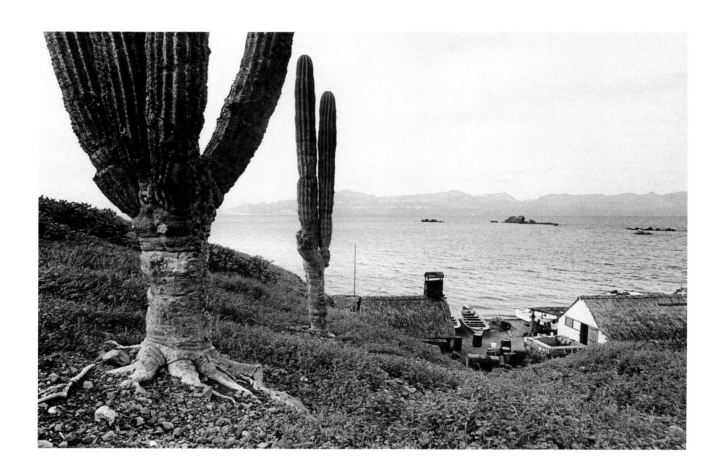

ISLA PARDITO, *Mexico.*

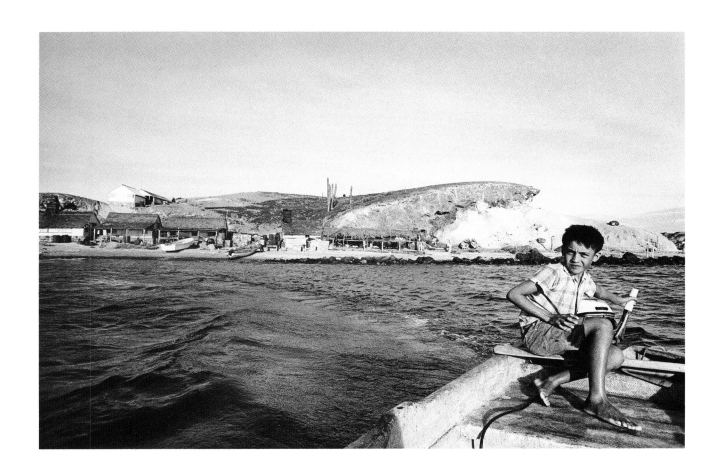

GILBERTO WITH HIS PANGA, *Isla Pardito, Sea of Cortez, Mexico.*

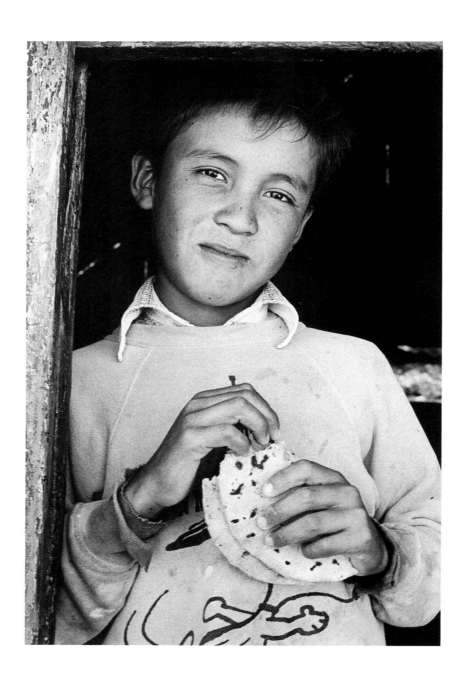

GILBERTO, *Isla Pardito, Sea of Cortez, Mexico.*

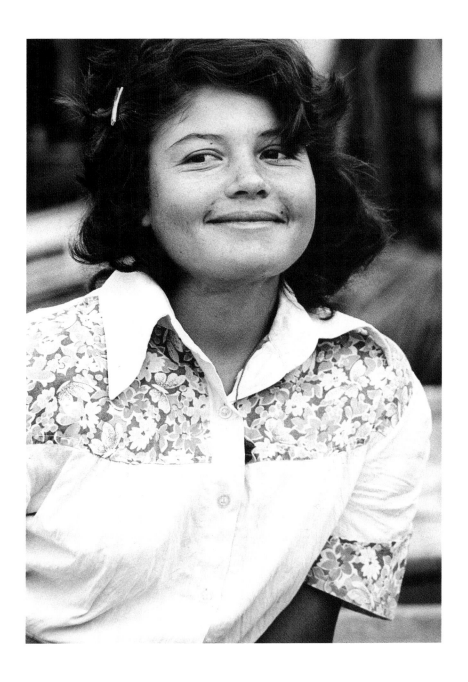

SOCORRO, *Isla Pardito, Sea of Cortez, Mexico.*

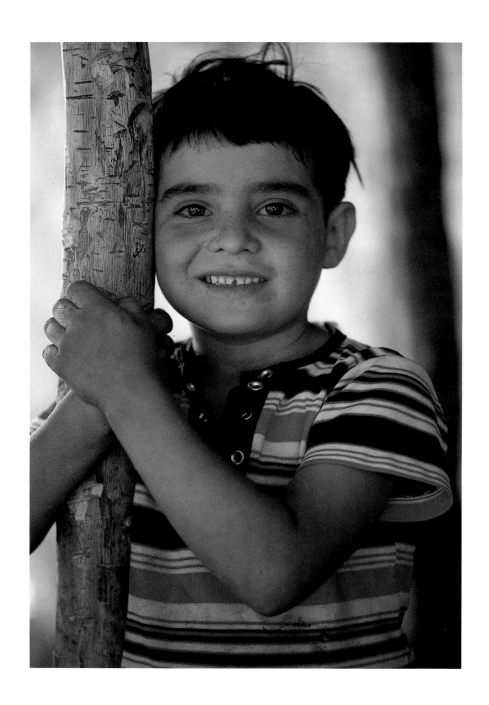

BOY IN A RANCHERIA, *East coast of Baja California.*

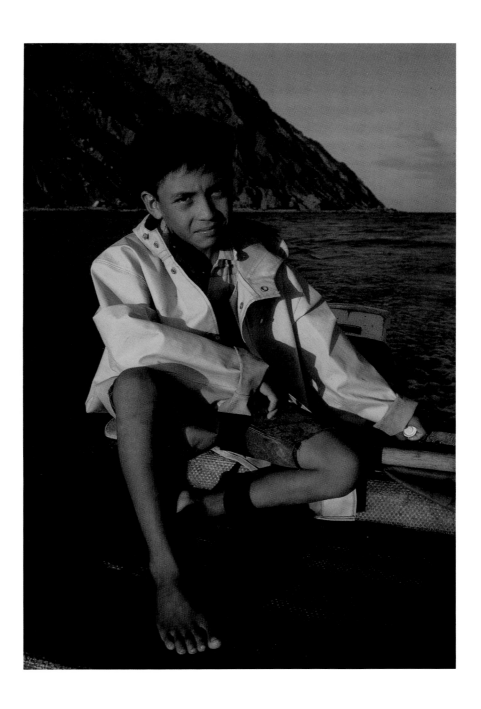

GILBERTO, *Isla Pardito, Sea of Cortez, Mexico.*

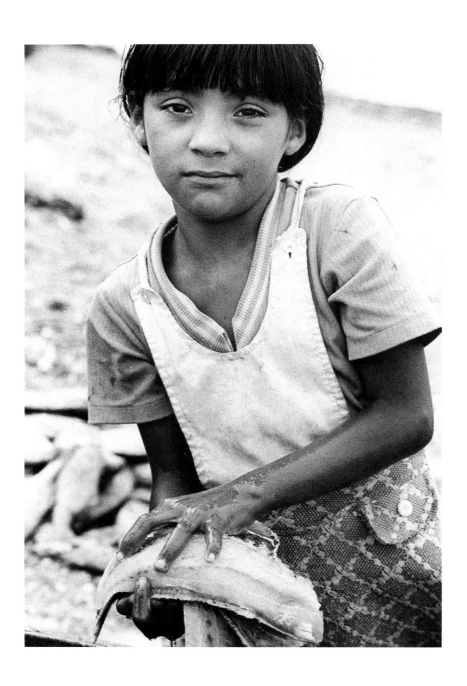

ELVIA, *Isla Pardito, Sea of Cortez, Mexico.*

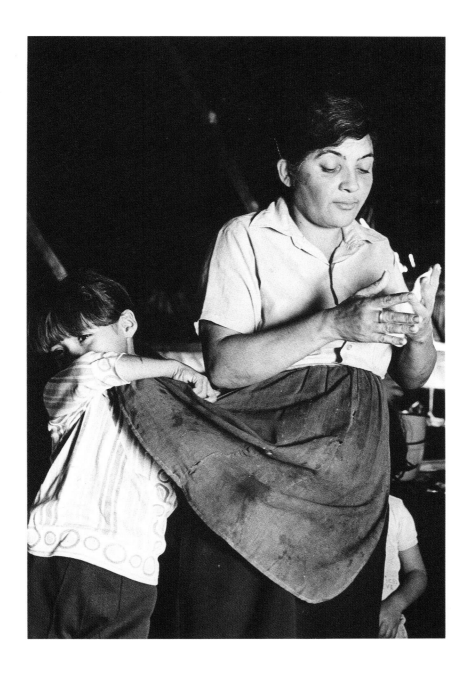

ENRIQUETA CUEVAS-AMADOR WITH ELVIA, *Isla Pardito, Sea of Cortez, Mexico.*

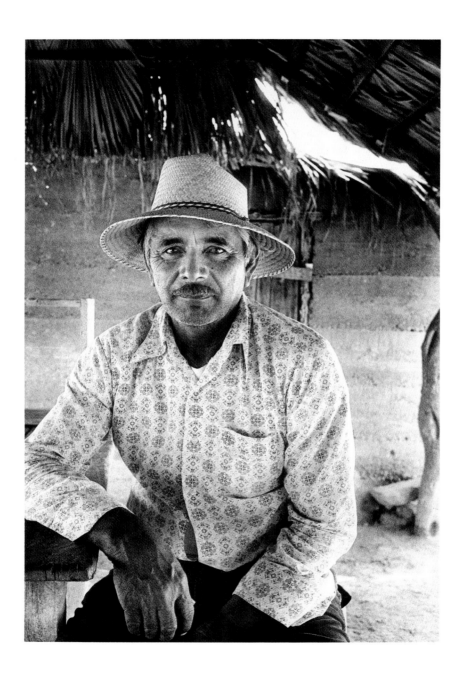

SOLOMON, *East coast of Baja California.*

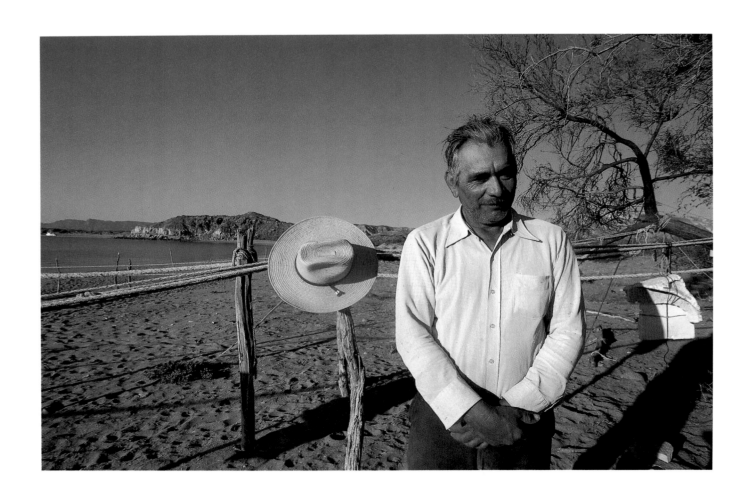

SOLOMON, *East coast of Baja California.*

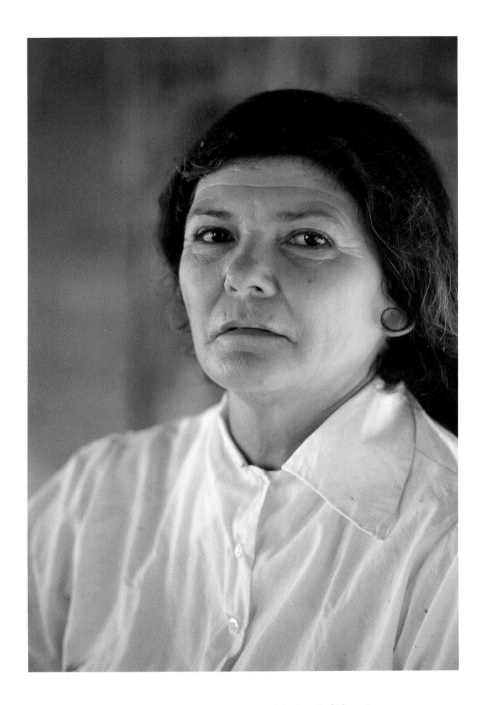

ANASTASIA, *East coast of Baja California.*

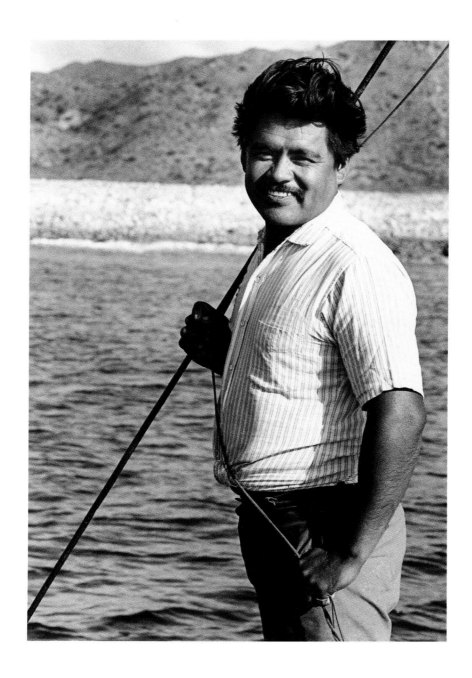

JOSE CUEVAS-AMADOR, *Sea of Cortez, Mexico.*

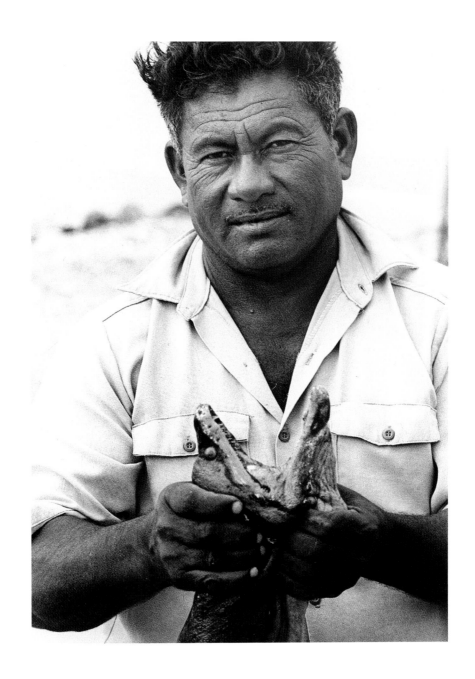

JUAN CUEVAS-AMADOR, *Isla Pardito, Sea of Cortez, Mexico.*

*We caught two boat-loads of fish today. Literally two boats filled to the gunnels with fish. It took us till two in the morning to clean them all. Everybody worked. Everybody was happy.*

(JOURNAL: 11/9/75)

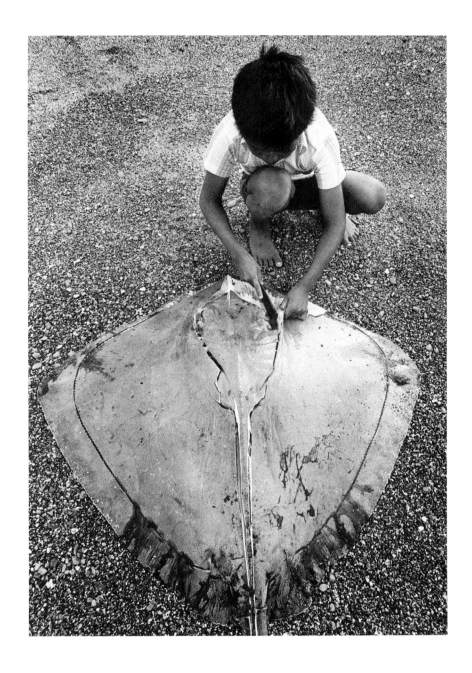

GILBERTO CLEANING A STING RAY, *Isla Pardito, Sea of Cortez, Mexico.*

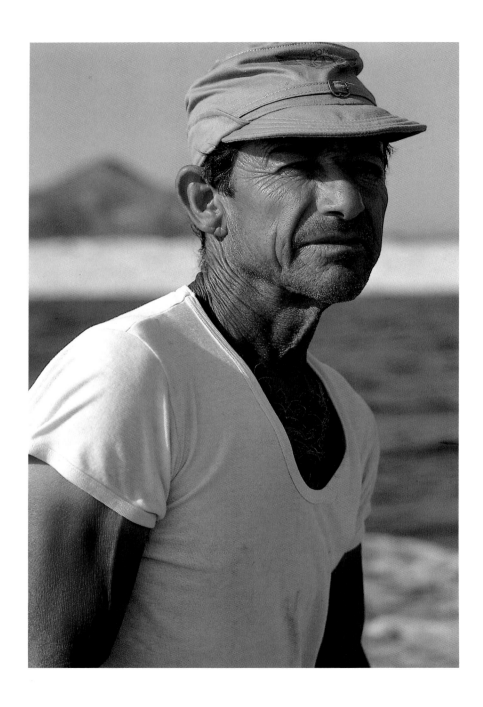

ERNESTO, *Sea of Cortez, Mexico.*

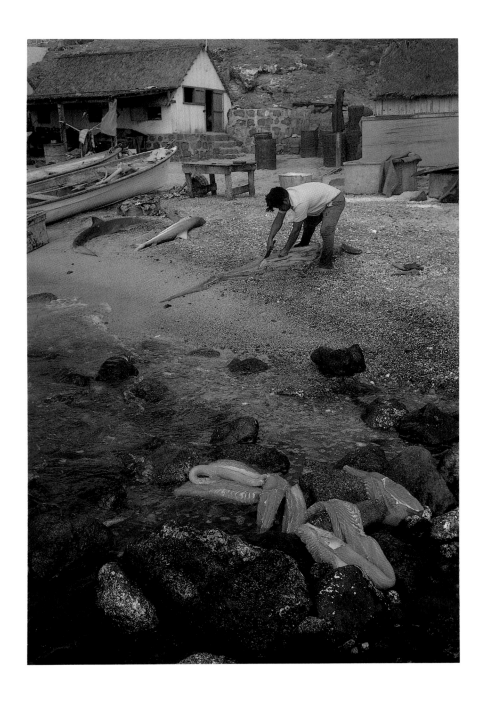

CLEANING SHARKS, *Isla Pardito, Sea of Cortez, Mexico.*

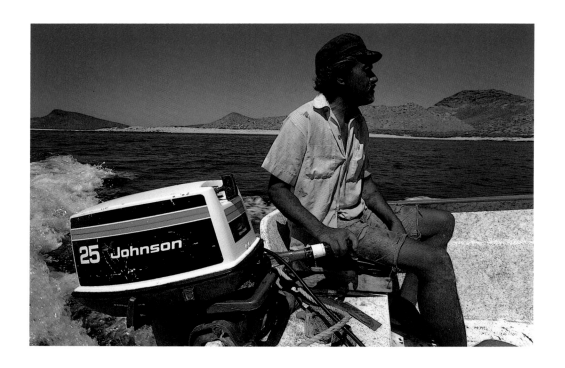

VAGABONDO, *Sea of Cortez, Mexico.*

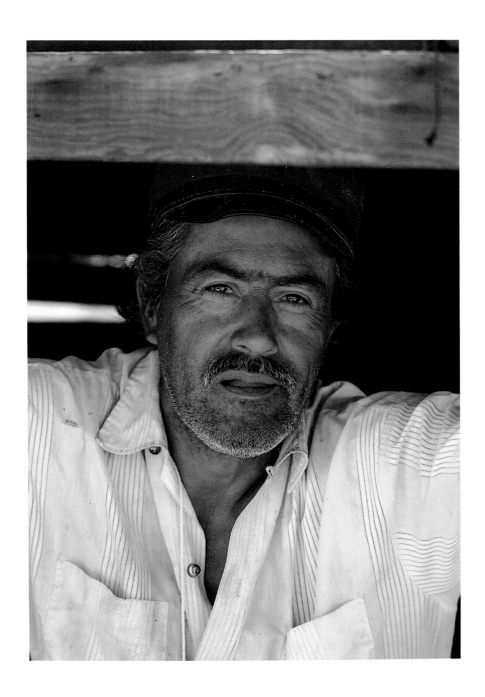

VAGABONDO, *Sea of Cortez, Mexico.*

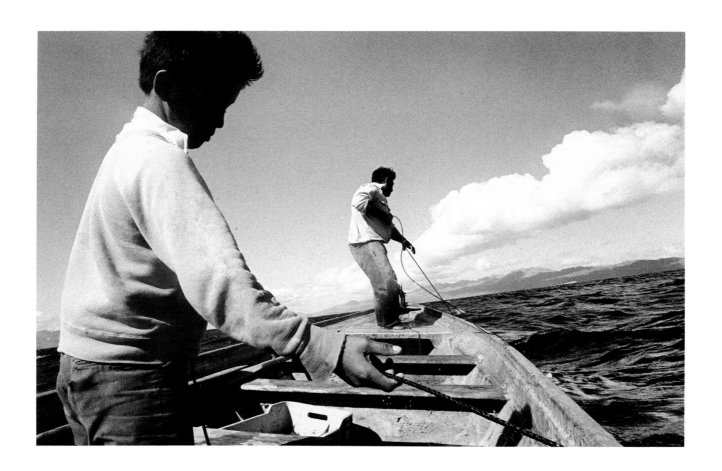

GILBERTO AND JUAN, *Sea of Cortez, Mexico.*

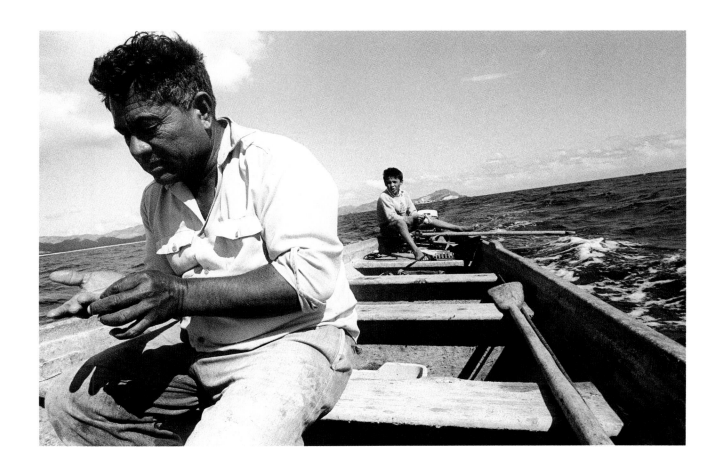

GILBERTO AND JUAN, *Sea of Cortez, Mexico.*

*I went to check the set lines with Gilberto and Juan this after-
noon. We caught five big sharks, including a hammerhead. For
thirty minutes or so I thought we wouldn't get there. Gilberto was
running the boat, Juan was in the bow when the motor sputtered
and stopped. We were a long way from shore, but Juan said, "No
problem. We have tools." The tool kit consisted of a file, a screw-
driver, a crescent wrench, a piece of bailing wire, and two spark
plugs. First Juan checked the gas. We had plenty. The motor still
wouldn't start. Next Juan changed the spark plugs and checked
them by shorting them out against the shaft of the outboard. They
had "fire." He pulled the starter cord; again and again we had fire
but the motor wouldn't start. We had gas, and the spark plugs had
spark. Now Juan took the gas line off the motor and tried to blow
through it. No blow. He reached into the oiled sock that held the
tool kit, took the bailing wire and pooked some gunk out of the
gas line. Then he blew through it, replaced it, pulled the starter
cord, once, twice; the motor jumped to life, he put it in gear, and
we were off to check the lines.*

<div align="right">(JOURNAL: 11/10/75)</div>

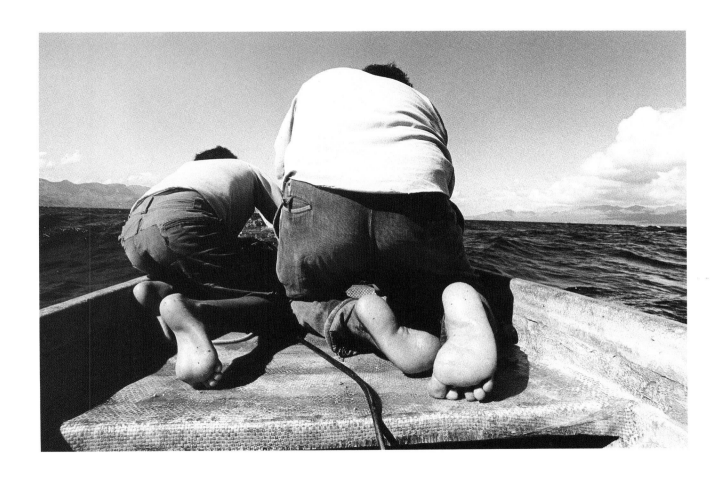

GILBERTO AND JUAN, *Sea of Cortez, Mexico.*

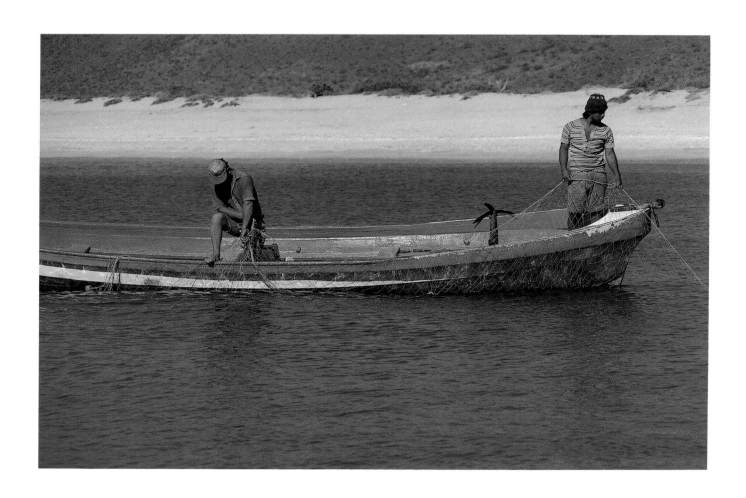

VAGABONDOS, *Sea of Cortez, Mexico.*

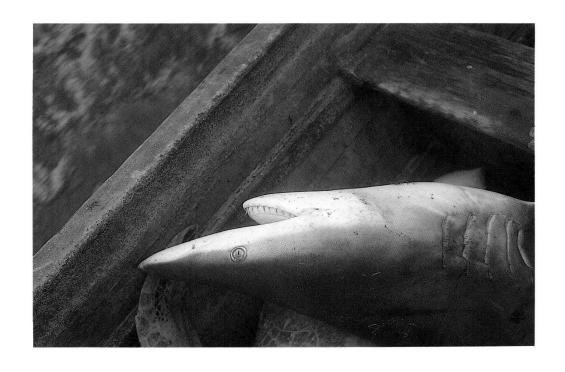

SHARK, *Sea of Cortez, Mexico.*

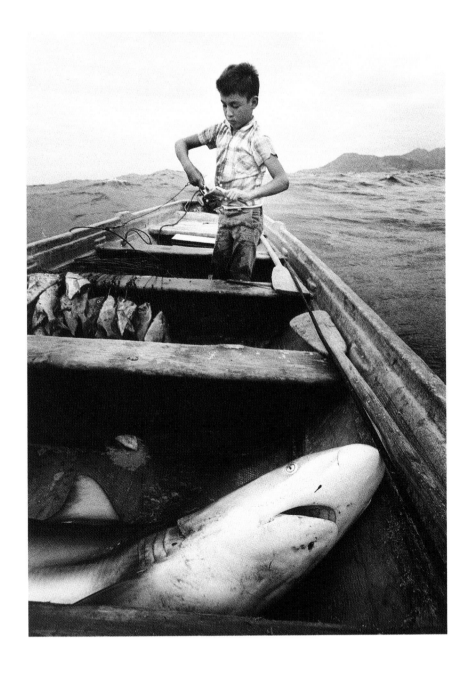

GILBERTO AND A SHARK, *Sea of Cortez, Mexico.*

# Photographer's Notes

**A**LL OF THE PHOTOGRAPHS in this book were made with 35mm cameras, some with a Leica range finder, but most with single-lens-reflex cameras. I usually use a hand-held incident light meter to determine exposures. The black-and-white work was shot on Tri-X, rated at ISO 400; most of the color work was shot on Kodachrome 64.

When I travel, I carry at least two camera bodies with a variety of lenses. There is always the trade-off between carrying all the equipment I might need and traveling light. When I fly, I carry all my cameras, lenses, and film with me because I never know if or when my baggage will arrive. When I am actually out working, I will lighten my film and camera load to accommodate the particular situation. When working around water and in boats, I carry my equipment in war surplus 20mm ammunition cans; they are waterproof and are big enough to hold a light camera bag and film, the lids open and close quickly, and I know

from experience they are watertight even if the boat capsizes.

When I am out shooting, I usually carry a short telephoto—a 105mm or 180mm—on one camera body and a wide-angle—a 20mm or 24mm—lens on the other body. I load the priority film I happen to be working with in both cameras because I'm easily confused if I shoot with color in one camera and black and white in the other. So I load my low-priority film in my range-finder camera because then there is a whole different feel to that camera, so at least my hands will know the difference.

I shoot in both color and black and white. I process my black and white in D-76 diluted one to one, and make prints with a cold light head on my enlarger. I process the prints in Dektol diluted at one to two. I reprinted all of the black-and-white prints for this book to 8 x 12 inches on 11 x 14 inch Ilford RC Deluxe paper. All of the color work in this book was shot on Kodachrome, processed in Kodak laboratories.

**p. II**: Gaza fisherman and son, Occupied Gaza Strip. Leica M-2, Tri-X film, 35mm lens.

**p. VIII**: Mr. and Mrs. Algodin, Sierra Madres, Mexico. I camped on the Algondin's land when I worked with the Tarahumara Indians of Mexico. Archibaldo would bring firewood; Mrs. Algodin would send homemade tortillas. I was invited up for dinner one afternoon and made this picture. It was the first time they had been photographed together since their marriage twenty-six years ago. Leica M-2, Tri-X, 35mm lens.

**p. 4**: Man with prayer beads, Aglun Camp, Jordan. I love the light that comes through open doorways. I made this picture just before a wedding and just before the sun went down. Nikon F-2, Kodachrome 64, 35mm lens.

## Palestine

**p. 6**: Baqaa Camp, Jordan. I had spent all of my time walking through the camp. One afternoon I walked up on a hill adjacent to the camp and looked down. Nikon F-2, Kodachrome 64, 180mm lens.

**p. 10**: Mr. Kalihl, UNRWA (United Nations Relief and Works Agency) Headquarters, Baqaa Camp, Jordan. More of that doorway light; I asked the director of the camp to sit in that light. Nikon F-2, Kodachrome 64, 24mm lens.

**p. 12**: Hadj, Baqaa Camp, Jordan. A man who has made the pilgrimage to Mecca is called a Hadj; it is a term of respect for older men. Nikon F-2, Kodachrome 64, 105mm lens.

**p. 13**: Elias, Ammān, Jordan. Elias is a guide at a ruined Roman amphitheater in Ammān, Jordan. Nikon F-2, Kodachrome 64, 180mm lens.

**p. 14**: Hadj, Rashidieh Camp, Lebanon. I made this portrait outside of a Swedish medical facility. He was waiting for his daughter-in-law. Nikon F-2, Kodachrome 64, 105mm lens.

**p. 15**: Tattooed woman, Baqaa Camp, Jordan. If you know how, you can tell where a woman is from by her facial tattoos; the custom has died out, however, in the past thirty years. Nikon F-2, Kodachrome 64, 105mm lens.

**p. 16**: Yasser Arafat, Beirut, Lebanon. I had never seen a kind portrait of Yasser Arafat in an American newspaper or magazine. I was determined to make one. Nikon F-2, 2 Vivitar 283 strobes, Kodachrome 64, 105mm lens.

**p. 18**: Carpenter, Al Hussein Camp, Jordan. This man was helping his friend roof a second-floor addition to his house. Nikon F-2, Kodachrome 64, 105mm lens.

**p. 19**: Trade school student, Occupied Gaza Strip. The young man was standing behind his lathe. He picked up a wrench and held this pose when I asked him if I could take his picture. Nikon F-2, Kodachrome 64, 180mm lens.

**p. 20**: Tomato seller, Occupied Gaza Strip. I made this picture in the souk, or market, at Gaza town. Nikon F-2, Kodachrome 64, 180mm lens.

**p. 21**: Farmer, Rashidieh Camp, Lebanon. He posed for his portrait in the fields adjacent to his home. Nikon F-2, Kodachrome 64, 105mm lens.

**p. 22**: Welder, Ammān, Jordan. When I first reached Ammān, Jordan, it took some time to adjust, so I spent much of that time walking the streets. I looked inside a big set of doors and saw this man working. Nikon F-2, Kodachrome 64, 20mm lens.

**p. 23**: Glass worker, Hebron, Occupied West Bank. Hebron has been known for its glass for centuries, and this man follows that tradition. Nikon F-2, Kodachrome 64, 105mm lens.

**p. 24**: Headmaster, Boys School Number 1, Baqaa Camp, Jordan. The schools ran in three shifts at Baqaa Camp, because there were too few of them and everyone wanted to attend. For the Palestinians, education is a weapon in the struggle for a homeland. Nikon F-2, Kodachrome 64, 105mm lens.

**p. 25**: Doctor, Occupied Gaza Strip. This doctor stood in the doorway of his small medical facility for his portrait. He was busy, overworked, and could only stand still for a minute. Nikon F-2, Kodachrome 64, 35mm lens.

**p. 26**: Sheik at a wedding, Rashidieh Camp, Lebanon. The term sheik should really be used for a religious man, not an oil-rich Arab. Nikon F-2, Kodachrome 64, 35mm lens.

**p. 27**: Mohammed Ramadan Hamad, olive farmer, Baqaa Camp, Jordan. This man was growing olive trees in tin cans to replace the trees that had been torn from his olive groves on the Occupied West Bank. Nikon F-2, Kodachrome 64, 35mm lens.

**p. 28**: Knitter, Al Breh, Occupied West Bank. This woman worked with a group of women knitting sweaters for Palestinian political prisoners locked in Israeli jails. Nikon F-2, Kodachrome 64, 35mm lens.

**p. 29**: Two Hadjs at a wedding, Rashidieh Camp, Lebanon. I was lucky to happen on a wedding celebration. It was a good place to make pictures. Nikon F-2, Kodachrome 64, 105mm lens.

**p. 30**: Mrs. Radwan Hudhud with bread, Al Hussein Camp, Jordan. I smelled the bread baking in the stairway of an apartment building and came upon this woman making bread on the fourth-floor landing. Nikon F-2, Kodachrome 64, 105mm lens.

**p. 31**: Making bread, Al Hussein Camp, Jordan. There was just enough light coming through a skylight to be able to make this picture. Nikon F-2, Kodachrome 64, 20mm lens.

**p. 33**: Omm Nasser, Rashidieh Camp, Lebanon. I made this picture with morning light as Miriam prepared breakfast. Nikon F-2, Kodachrome 64, 105mm lens.

**p. 34**: Woman at her gate, Jalazone Camp, Occupied West Bank. This woman looked out of her gate to see who was going by. I smiled, pointed to my camera, tilted my head; she smiled and nodded yes. Nikon F-2, Kodachrome 64, 105mm lens.

**p. 35**: Young woman in traditional dress, Al Breh, Occupied West Bank. I visited a school for Palestinian girls in Al Breh, where they also had a small museum. Again, I made a portrait in that wonderful doorway light. Nikon F-2, Kodachrome 64, 105mm lens.

**p. 36**: Boy with flute, Baqaa Camp, Jordan. I don't usually have preconceived pictures in my mind when I travel, but this photograph was an exception. When I left home, I knew I wanted to make a photograph of a Palestinian with a flute rather than an automatic weapon. Nikon F-2, Kodachrome 64, 180mm lens.

**p. 37**: School for the blind, Occupied Gaza Strip. I made this photograph of a beautiful girl, a student in the UNRWA school for the blind. She was unaware of the gentle window light that illuminated her. Nikon F-2, Kodachrome 64, 105mm lens.

**p. 39**: Man in doorway, Aglun Camp, Jordan. That doorway light again. I often try to duplicate it in my studio but never quite succeed. Nikon F-2, Kodachrome 64, 105mm lens.

**p. 40**: The Mansur family, Baqaa Camp. I encountered only warm hospitality, never hostility, from the Palestinian people. Every place I went, I was greeted with welcomes and offers to share meals. Nikon F-2, Kodachrome 64, 105mm lens.

**p. 41**: Mrs. Mansur, Baqaa Camp, Jordan. Mrs. Mansur is holding the framed name of Allah. Nikon F-2, Kodachrome 64, 105mm lens.

**p. 42**: Girl with a painting of Lena Nabulsi, Ammān, Jordan. Lena Nabulsi was killed in Bethlehem, on the Occupied West Bank, by Israeli soldiers on her way home from school. Her martyrdom is represented in this painting, which has become an icon symbolizing the Palestinian struggle. Nikon F-2, Kodachrome 64, 180mm lens.

**p. 43**: Girl with a photograph of her martyred father, Ammān, Jordan. I asked the girl to hold the picture of her father, framed together with the Palestinian flag and a clipping of Yasser Arafat, and stand in the doorway of her little house so I could take this picture. Nikon F-2, Kodachrome 64, 105mm lens.

**p. 44**: Sofia Ramadan Omm Mohammed, Rashidieh Camp, Lebanon. I described my meeting with Omm Mohammed earlier. After she agreed to let me make her picture, I asked her to move out of the noonday sun into the shade of a building. Nikon F-2, Kodachrome 64, 105mm lens.

**p. 45**: Omm Mohammed's younger son, Mohammed (*left*), and older son, Radwan (*right*), Rashidieh Camp, Lebanon. I was moved by Omm Mohammed's story and made a close-up picture of each side of her locket. Nikon F-2, Kodachrome 64, 55mm macro lens.

**p. 46**: Four brothers from Burj-El-Barajaneh, Lebanon, 1983. I made this photo in the window light of my own studio in Flagstaff, Arizona. Radda, in the center, has become my close friend. He and his two younger brothers were studying at Northern Arizona University. Their older brother, Bassam, whose photograph rests on the chair, was killed in the South of Lebanon. Leica M-2, Kodachrome 64, 35mm lens.

**p. 47**: Abo Tarik Salameh and son, Shatila Camp, Lebanon. I made this father and son portrait on my last day in Beirut. Nikon F-2, Kodachrome 64, 105mm lens.

**p. 48**: Children in bomb shelter, Rashidieh Camp, Lebanon. I couldn't help but think of my own children as I photographed these children in the doorway of the bomb shelter located in their school yard. Nikon F-2, Kodachrome 64, 20mm lens.

**p. 49**: Boy in a plowed field, Baqaa Camp, Jordan. Sometimes I don't see the symbolism of a picture as I take it, but it becomes apparent when I return home and see it on my light table. Nikon F-2, Kodachrome 64, 24mm lens.

## Trinidad

**p. 50**: Road to Toco Village, Trinidad, West Indies. Sometimes you go looking for pictures and find them. Nikon F, Kodachrome 64, 200mm lens.

**p. 53**: Boy on Toco Village road, Trinidad, West Indies. Children all over the world are inventive and love to play. Nikon F, Kodachrome 64, 105mm lens.

**p. 55**: Boy on Toco Village road, Trinidad, West Indies. It is the photographer's job to take advantage of favorable conditions and opportunities, and then organize them into pictures. Nikon F, Kodachrome 64, 200mm lens.

**p. 56**: School girl, Port of Spain, Trinidad, West Indies. I wanted to do a series of photographs of young Trinidadians in their school uniforms. I never really finished the series, but every time I see this picture, I think I still want to do it. Nikon F, Kodachrome 64, 105mm lens.

**p. 57**: School girl, Mayaro, Trinidad, West Indies. Beautiful people, tropical light, and color are wonderful things to find in front of your camera. Nikon F, Kodachrome 64, 200mm lens.

**p. 58**: Lester, Matelot Village, Trinidad, West Indies. I will often ask people to pose for their portrait adjacent to signs because I think the graphics can add to a photograph. Nikon F, Tri-X, 35mm lens.

**p. 59**: Villager, Matelot Village, Trinidad, West Indies. Doorways work in black and white as well as color. Nikon F, Tri-X, 105mm lens.

**p. 60**: Mr. Soman's son, Trinidad, West Indies. People often ask me which I like better, color or black and white. I love them both. It's like having two lovers. Nikon F, Kodachrome 64, 105mm lens.

**p. 61**: Mr. Soman's daughter, Trinidad, West Indies. Eyes. I try to focus on the eyes. Nikon F, Kodachrome 64, 105mm lens.

**p. 62**: Rice harvest, Trinidad, West Indies. The next two pictures illustrate the merit of working with two camera bodies with two very different lenses. I made this photograph with a wide-angle lens and framed the shot with the prism off the camera, looking down into the viewfinder, while holding it very close to the surface of the water. Nikon F, Kodachrome 64, 20mm lens.

**p. 63**: Rice harvest, Trinidad, West Indies. After looking around with my wide-angle lens, I like to look around with a telephoto. Nikon F, Kodachrome 64, 200mm lens.

**p. 65**: Mr. Soman with his family, Trinidad, West Indies. Nikon F, Kodachrome 64, 20mm lens.

**p. 66**: Rice harvest, Trinidad, West Indies. Nikon F, Kodachrome 64, 200mm lens.

**p. 67**: Fishing beach, Matelot Village, Trinidad, West Indies. A girl is carrying a fish home from the fishing beach for her family's dinner. Nikon F, Kodachrome 64, 105mm lens.

**p. 69**: Fishing beach, Matelot Village, Trinidad, West Indies. Open shade offers wonderful light for black and white. Sometimes you have to be cautious about open shade and color, because it might want to turn blue. Nikon F, Tri-X, 105mm lens.

**p. 71**: Fishing beach, Matelot Village, Trinidad, West Indies. Open shade under the roof of the fishing shed, with a net for a background. My friend Dede is posing with a couple of pounds of grouper wrapped in a leaf. Nikon F, Tri-X, 105mm lens.

**p. 72**: Cocoa shed, Matelot Village, Trinidad, West Indies. Most of the people in Matelot Village were fishermen, but some, like Mr. Tunn, worked in the bush gathering cocoa, nutmegs, and coffee. Leica M-2, Kodachrome 64, 35mm lens.

**p. 73**: Local shop, Matelot Village, Trinidad, West Indies. I enjoyed visiting the small shops in the village and tried to purchase a little something from them each day. It was a good way to meet people. Leica M-2, Kodachrome 64, 35mm lens.

**p. 74**: Mr. Bellot, piano tuner, Port of Spain, Trinidad, West Indies. I was walking down a Port of Spain street when I heard Chopin flowing out of an open doorway. I listened and waited for Mr. Bellot to pause and then asked him if I could make his picture. Leica M-2, Kodachrome 64, 35mm lens.

**p. 75**: Baby Soman, Trinidad, West Indies. I photographed "Baby Soman" on his porch. He was becoming a famous cricket player. Nikon F, Kodachrome 64, 105mm lens.

**p. 76**: Mrs. Findley, Matelot Village, Trinidad, West Indies. I met Mrs. Findley on the road almost every day. We usually greeted each other and passed the time of day. I'd usually ask her if I could take her picture, and she'd always reply, "Oh no, not today. I look such a mess," or some similar answer. One day we passed on the road, and she was all dressed up, returning from marketing in the village. She then allowed me to take her picture. Nikon F, Kodachrome 64, 24mm lens.

**p. 77**: Mrs. Findley, Matelot Village, Trinidad, West Indies. Nikon F, Kodachrome 64, 105mm lens.

**p. 78**: Mr. and Mrs. Gludd, Matelot Village, Trinidad, West Indies. Mr. and Mrs. Gludd were my closest neighbors in Matelot Village. They lived diagonally across the street, and we would often visit on the porch as the afternoon cooled. Leica M-2, Kodachrome 64, 35mm lens.

**p. 79**: Front step, Matelot Village, Trinidad, West Indies. I saw this one morning on my way home from visiting one of the village shops. Nikon F, Kodachrome 64, 200mm lens.

**p. 80**: Gloria with her two daughters, Matelot Village, Trinidad, West Indies. I'd see Gloria each morning at the fishing beach. To me, she epitomized womanhood and motherhood. Nikon F, Tri-X, 35mm lens.

**p. 81**: Gloria with her older daughter, Matelot Village, Trinidad, West Indies. Nikon F, Tri-X, 105mm lens.

**p. 83**: Gloria with her younger daughter, Matelot Village, Trinidad, West Indies. Nikon F, Tri-X, 105mm lens.

**p. 84**: Village girl, Matelot Village, Trinidad, West Indies. I saw this girl walking toward me; we smiled, greeted each other, and passed. I waited a few minutes and then followed her home. I knocked on the door, and her mother answered. "May I take your daughter's picture," I asked. She said, "Yes, but have some cooling drink first." Nikon F, Tri-X, 105mm lens.

**p. 85**: Taheed, a fisherman, Matelot Village, Trinidad, West Indies. Most of the people in Matelot are of African descent; Taheed is East Indian. I love to see my own reflection in the eyes of the people I photograph. Nikon F, Tri-X, 105mm lens.

**p. 86**: Mr. and Mrs. Gludd, Matelot Village, Trinidad, West Indies. I made this photograph during an afternoon visit. Nikon F, Tri-X, 105mm lens.

**p. 87**: Mr. Gludd, Matelot Village, Trinidad, West Indies. Nikon F, Tri-X, 105mm lens.

**p. 89**: Man on the Matelot road, Matelot Village, Trinidad, West Indies. During the afternoon, the road became a linear studio: an adjacent mountain blocked the direct light of the sun, but there was a large expanse of bright sky. The light was wonderful —great for pictures. Nikon F, Tri-X, 105mm lens.

## Mexico

**p. 90**: Isla Pardito, Mexico. This was the scene that greeted me each morning as I awoke from sleeping on the porch of Pepe's house. Leica M-2, Kodachrome 64, 35mm lens.

**p. 94**: Isla Pardito, Mexico. Isla Pardito is small, about three acres. Three cardon cacti grew at the high spot of the island. Nikon F, Tri-X, 24mm lens.

**p. 95**: Gilberto with his panga, Isla Pardito, Sea of Cortez, Mexico. Some boys have skateboards or bikes; Gilberto had his panga, a boat of a traditional design worthy of the unpredictable waters of the Sea of Cortez. Nikon F, Tri-X, 24mm lens.

**p. 96**: Gilberto, Isla Pardito, Sea of Cortez, Mexico. The doorway shot again. Gilberto was raiding his mother's kitchen for fresh tortillas when I caught him. Nikon F, Tri-X, 105mm lens.

**p. 97**: Socorro, Isla Pardito, Sea of Cortez, Mexico. Socorro always had a smile. She gave me a beautiful shell as I was leaving Isla Pardito. Nikon F, Tri-X, 105mm lens.

**p. 98**: Boy in a rancheria on the east coast of Baja California. This boy allowed me to practice my Spanish. *"Quesiero un photo de usted, por favor?"* He smiled. *"Si. Por que no."* Nikon F, Kodachrome 64, 105mm lens.

**p. 99**: Gilberto, Isla Pardito, Sea of Cortez, Mexico. Gilberto and I went to an adjacent island to gather wood. It had been raining when we left Pardito, which gave him a chance to wear his new slicker. Nikon F, Kodachrome 64, 105mm lens.

**p. 100**: Elvia, Isla Pardito, Sea of Cortez, Mexico. Gilberto's younger sister helped wash filleted fish before it was salted. Nikon F, Tri-X, 105mm lens.

**p. 101**: Enriqueta Cuevas-Armador and Elvia, Isla Pardito, Sea of Cortez, Mexico. While the men fished, Gilberto's mother spent much of her time in her kitchen preparing food for the day. Nikon F, Tri-X, 35mm lens.

**p. 103**: Solomon, east coast of Baja California. This is the man I take pictures for, the muse on my shoulder. Leica M-2, Tri-X, 35mm lens.

**p. 104**: Solomon, east coast of Baja California. I made this picture three years after I first met Solomon. Leica M-2, Kodachrome 64, 35mm lens.

**p. 105**: Anastasia, east coast of Baja California. I made this photo in the shade of a ramada the first time we met. Nikon-F, Kodachrome 64, 105mm lens.

**p. 106**: Jose Cuevas-Armador, Sea of Cortez, Mexico. Gilberto's father, Pepe, usually stood in the bow of the panga as his son motored from place to place. I was shooting from another panga paralleling Gilberto and his father. Nikon-F, Tri-X, 200mm lens.

**p. 107**: Juan Cuevas-Armador, Isla Pardito, Sea of Cortez, Mexico. Juan is holding a moray eel that he killed when it swam onto the beach, attracted by the smell of the fish we were cleaning. Nikon F, Tri-X, 200mm lens.

**p. 109**: Gilberto cleaning a sting ray, Isla Pardito, Sea of Cortez, Mexico. Gilberto was cleaning the day's catch, while I was taking photographs from a really low angle. When I stood up to stretch my back, I saw this. Nikon F, Tri-X, 35mm lens.

**p. 110**: Ernesto, Sea of Cortez, Mexico. Ernesto took me from La Paz to Isla Pardito. Nikon F, Kodachrome 64, 105mm lens.

**p. 111**: Cleaning sharks, Isla Pardito, Sea of Cortez, Mexico. The work for the day was nearly finished when I made this picture. Leica M-2, Kodachrome 64, 35mm lens.

**p. 112**: Vagabondo, Sea of Cortez, Mexico. "Vagabondos" is what they call the independent fishermen that catch sharks in the Sea of Cortez. Nikon F, Kodachrome 64, 24mm lens.

**p. 113**: Vagabondo, Sea of Cortez, Mexico. Doorways again; they are great places to make portraits. Nikon F, Kodachrome 64, 180mm lens.

**p. 114**: Gilberto and Juan, Sea of Cortez, Mexico. Nikon F, Tri-X, 24mm lens.

**p. 115**: Gilberto and Juan, Sea of Cortez, Mexico. Nikon F, Tri-X, 24mm lens.

**p. 117**: Gilberto and Juan, Sea of Cortez, Mexico. I was engrossed by the contrast in size between Gilberto and his Uncle Juan as they made repairs on their outboard motor. I especially liked the bottoms of their feet. Nikon F, Tri-X, 24mm lens.

**p. 118**: Vagabondos, Sea of Cortez, Mexico. Photographed from one boat to another. These are the times the large 20mm ammunition cans makes a great place for carrying camera equipment. Nikon F, Kodachrome 64, 180mm lens.

**p. 119**: Shark, Sea of Cortez, Mexico. I made some of these photographs soon after the movie *Jaws* was released. Leica M-2, Kodachrome 64, 35mm lens.

**p. 121**: Gilberto and a shark, Sea of Cortez, Mexico. This has to be one of my all-time favorite pictures. The seas were rough; Gilberto stood nonchalantly in the stern of the panga, baiting hooks, as his father hauled sharks into the bow of the boat. Nikon F, Tri-X, 24mm lens.